3 5674 03390515 0

IMAGES
of America

DETROIT'S MICHIGAN CENTRAL STATION

IMAGES
of America

DETROIT'S MICHIGAN
CENTRAL STATION

Kelli B. Kavanaugh

ARCADIA

First Printed 2001.
Reprinted 2002.

Published by Arcadia Publishing,
an imprint of Tempus Publishing, Inc.
3047 N. Lincoln Ave., Suite 410
Chicago, IL 60657

Printed in Great Britain.

Library of Congress Catalog Card Number: 2001094690

For all general information contact Arcadia Publishing at:
Telephone 843-853-2070
Fax 843-853-0044
E-Mail sales@arcadiapublishing.com

For customer service and orders:
Toll-Free 1-888-313-2665

Visit us on the internet at http://www.arcadiapublishing.com

CONTENTS

ACKNOWLEDGEMENTS

First and foremost, this book would undoubtedly never have been completed without the myriad contributions of my dear friend, Randa Haurani. Not only did Randa capture the Michigan Central on film in her own supremely beautiful manner, she also painstakingly photographically reproduced many of the historic images found in these pages. Her talent is trumped only by her modesty.

The staff of the Burton Historical Collection of the Detroit Public Library deserves a hearty round—of applause or beer, whichever they prefer. They oversee one of Detroit's jewels with efficiency and care. Special thanks go to Cheri Gay and David Poremba.

Another friend of mine who came to bat for this project was Dale Lauzon. Dale is responsible for the site and floor plans found on pages 15–20. Much appreciated, Dae.

A number of talented photographers did not hesitate to share their work with this project. Allan Barnes, Tom Rinaldi, Jeremy Marentette, Hans Veneman, and Mark Powell are surely gracious artists.

CJ Miller allowed use of not only his photographs, but also a lovely collection of memorabilia. Irina Nakhova was able to produce documentation of the intriguing art installation she curated for Wayne State back in 1995, and *Record Time*'s Mike Himes allowed Randa to photograph his poster of the rave once held at the depot.

I must mention the possessor of the most intimidatingly deep knowledge of the Michigan Central: Mr. Garnet Cousins, whose pictures and wisdom can be found many times throughout these pages. Talking with him filled me with a sense of both awe and inadequacy.

Heartfelt thanks also to Janice Harvey of the Taubman School of Architecture and Urban Planning at the University of Michigan, Alyn Thomas of Manning Brothers/Forbes Management, Brendan McKenna of Arcadia Publishing, Mike Clear, Dorothy Delphy, Dan and Jean Guyot, Luis Antonio Uribe, David M. Sheridan, Rebecca Vonesh, Scott Martin, the Detroit Imaging Company, and Larry and Jake Marmul.

I have been the beneficiary of a wonderful work environment, courtesy of Mark Faremouth and the many unique individuals that comprise the Corktown community. Finally, I must thank my muse, the city of Detroit. I would gladly argue with anyone who does not find her the most compelling city in America—and the most deserving of further recognition of her true place in American history.

I dedicate this book to Charlotte Barbara, Laurel Barbara, and Kati Lynn.

INTRODUCTION

The story of Detroit's Michigan Central Station is an engaging one, as it is not merely the tale of a singular structure. Its inception, glory, decline, and ultimate descent into abandonment and neglect dramatically parallels the story of the city in which it resides.

In 1913, the Michigan Central Station opened its majestic entrances to the people of Detroit. Designed by Warren & Wetmore and Reed & Stem, the firms also noted as the architects of the Grand Central Station in New York City, the depot was a marvel of grandeur and comfort for the traveler lucky enough to utilize its facilities.

The Michigan Central was sited west of downtown, with the theory being that the residential neighborhood situated between the station and the Central Business District, generally regarded as a slum, would be cleared as downtown inevitably expanded westward. This never happened. For some time, this was not a problem, as the trolley system in Detroit ably transported travelers to and from the station. However, when Detroit's trolley system was disbanded by 1956, travelers were left with a train station lacking both adequate parking and a viable alternative form of transit to get them to and from the station.

This single example is indicative of a larger pattern in Detroit, one of questionable planning and lingering repercussions. For this reason, it becomes important to see the Michigan Central as not only an exquisite structure, but also a metaphor for the entire city of Detroit.

The book focuses primarily, of course, on the Michigan Central: its construction, architecture, and historical facts. It also seeks to personalize the station with a chapter devoted entirely to images of people utilizing the station. Another chapter looks at its current condition, while the last chapter examines several imagined futures for the Michigan Central, as dreamed by architects, students, and preservationists. The final two renderings were contributed by the current owner of the train station, and document what I fervently hope will one day be a reality for this wonderful structure.

Every person who has ever glimpsed the Michigan Central Station has developed some sort of emotional attachment to it. The structure exudes a haunting power, its skeleton visible from freeways, the Ambassador Bridge, and the windows of many buildings. The neighborhoods surrounding it have in many ways altered their fortunes, reversed their decline, and increased their prosperity, yet the Michigan Central currently stands as a hulking ghost of its glory years.

At the very least, I hope this book honors the extraordinary structure of the Michigan Central Station. At the very most, I dream that it could, in some small way, help propel the station into a future better than the one a casual observer might predict. I trust that you will find pleasure in the wonderful images you are about to encounter, and I am thankful to have had the opportunity to present them to you.

Kelli B. Kavanaugh
Detroit, 30 August 2001

INDEX OF PHOTOGRAPHERS
AND CONTRIBUTORS

Each name is followed by page numbers—(t) signifies top of page, (b) signifies the bottom. (C) represents items that the individual contributed, (P) represents photos that were actually taken by him or her, and (R) represents a drawing or rendering produced by this person.

One

BACKGROUND

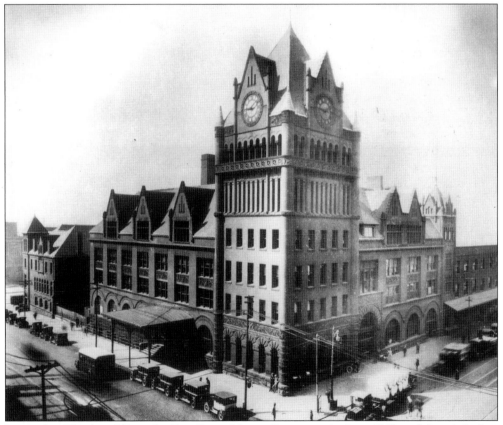

Located at Third and Fort, the Fort Street Union Depot was built in 1893 and demolished in 1974 to make way for Wayne County Community College's Downtown Campus. Fort Street carried passengers until the conception of Amtrak in 1971. (Courtesy of Manning Brothers Historic Photographic Collection)

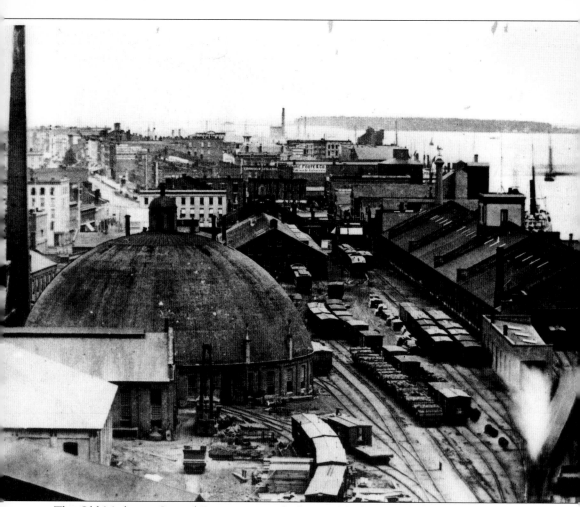

The Old Michigan Central Depot consisted of several buildings, of which the roundhouse is most prominent in this 1885 photograph. The roundhouse was used to service and repair engines and would have been connected to the main track by a spur, also referred to as a "stub." One of the reasons a new station was desired by the officers of the Michigan Central Railroad was to allow the "through" passage of trains, rather than this "stub-end" configuration. (Courtesy of the Burton Historical Collection)

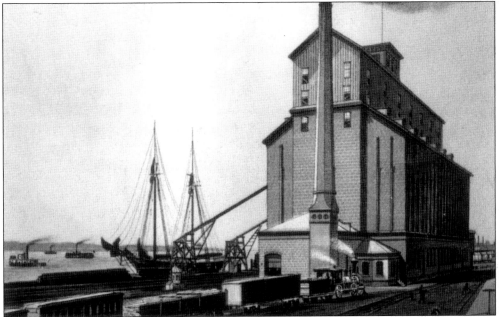

Built in 1883, the Old Michigan Central was part of a gritty Detroit riverfront that included both schooners and steam-propelled ferries—nearly unrecognizable to more modern eyes. The railroad's waterfront freight elevator is pictured here. (City of Detroit, Courtesy of the Burton Historical Collection)

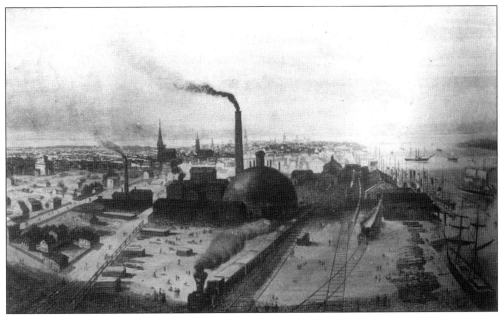

At 2:10 p.m. on Friday, December 26, 1913, a fire broke out at the soon-to-be-vacated Old Michigan Central. The clock tower began to blaze, and Michigan Central Railroad Chairman Henry B. Ledyard was forced to evacuate the building. Thus, the new Michigan Central Station received its first train at 5:20 p.m. the same day, although its formal gala opening was not scheduled to take place until January 4, 1914. (Courtesy of the Burton Historical Society)

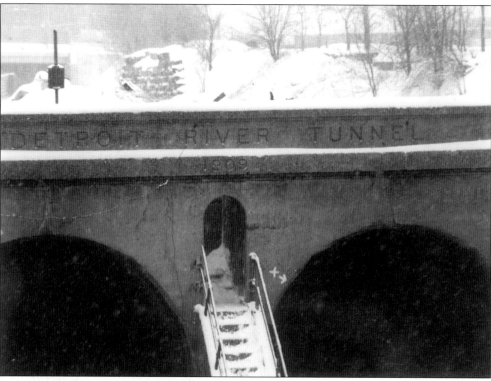

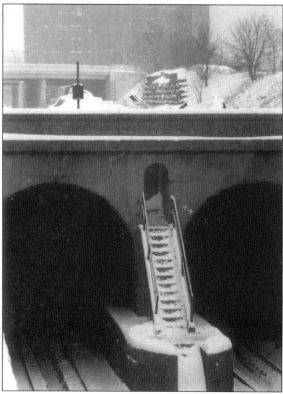

A 1905 reorganization of the Detroit River Tunnel Company, following several earlier aborted attempts to connect Windsor and Detroit via tunnel under the Detroit River, successfully constructed the Detroit River Tunnel. Michigan Central Railroad then began planning for a new depot to be located within one-half mile of the tunnel's western portal, one factor in the selection of the Michigan Central Station's site. (Courtesy of the Corktown Citizens District Council)

The tunnel was aligned to minimize interference from car-ferries and existing railroad structures. In an effort to cut down on street crossings, an elevated portion of track work extended for 2.5 miles to west Detroit's shops and yards. The Detroit River Tunnel was completed in 1909. (Courtesy of the Corktown Citizens District Council)

Two
SITE/PLANS/AERIALS

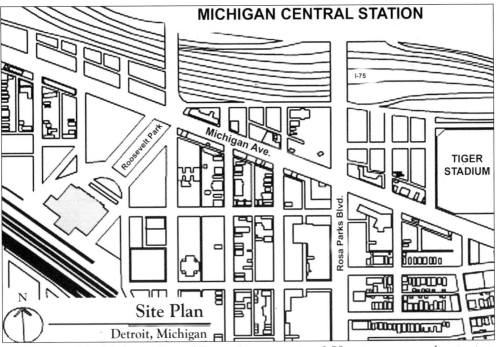

MICHIGAN CENTRAL STATION

I-75

Roosevelt Park

Michigan Ave.

Rosa Parks Blvd.

TIGER STADIUM

N

Site Plan

Detroit, Michigan

At the time of the Michigan Central Station's construction, I-75 was not even a glimmer in an engineer's eye, yet this site plan reveals its proximity to the depot, as well as its dominance of the landscape.

The freeway's construction reduced Corktown, situated between the depot and downtown, and Mexicantown, just southwest of the station, to fractions of their original expanses. These two neighborhoods, despite the difficulties posed by this loss of neighborhood cohesion, have soldiered on—the 2000 census posted a net population growth in the area.

The Michigan Central Station's floor plans can be found on the next five pages. Note the scale of the office tower to the main floor's sprawl. This disparity led some critics to see the depot as two buildings with little in common placed one atop the other.

MICHIGAN CENTRAL STATION

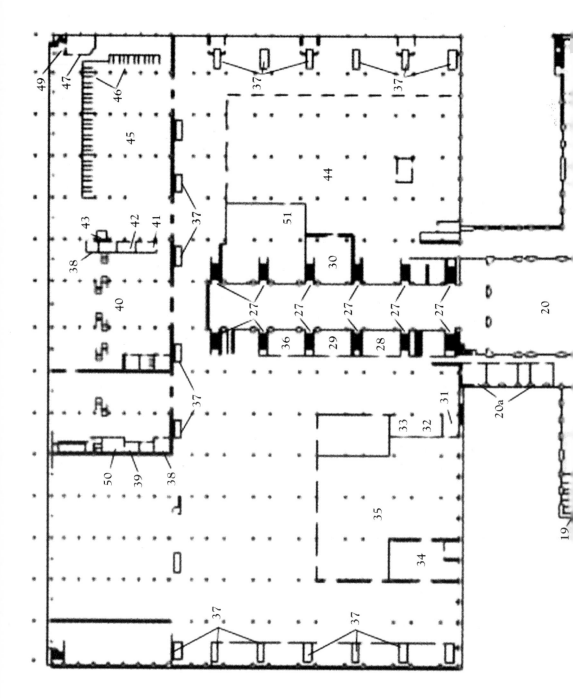

Ground Floor Plan & Shed

N

n.t.s

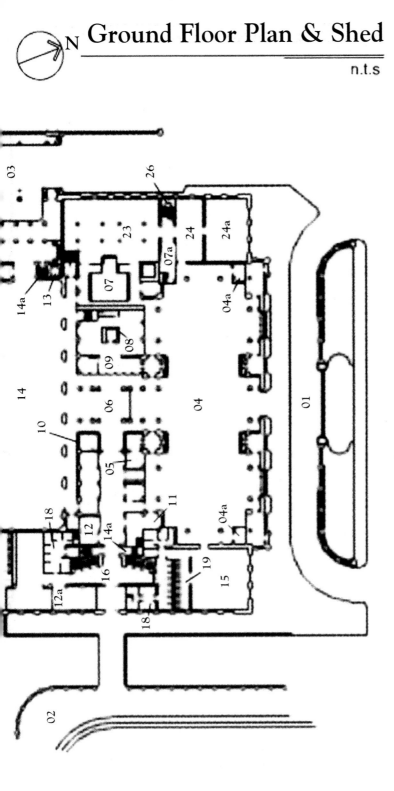

01	driveway
02	streetcar ent.
03	carriage ent.
04	waiting rm.
04a	telephones
05	newsstand
06	ticket lobby
07	lunch counter
07a	service
08	vault
09	ticket office
10	information
11	drug store
12	cigars
12a	barber shop
13	bioler flute
14	concourse
14a	stairs up
15	women's rm.
16	elevator hall
17	men's rm.
18	baths
19	tiolets
19a	smoking rm.
20	ramp dn. to trains
20a	customs
21	station mstr.
22	baggage rm.
23	restaurant
24	cafe
24a	reading rm.
25	stairs dn.
26	stairs up to trains
27	ramp
28	supply rm.
29	lamp rm.
30	bonded rm.
31	teamster's clerk
32	lavatory
33	railroad porters
34	parcel post
35	U.S. mail
36	telegraph rm.
37	elevators
38	icebox
39	value rm.
40	scales
41	refrigerator
42	perishable rm.
43	6-ton scale
44	baggage
45	American Express
46	sorting bins
47	drivers
48	bad order rm.
49	sheet writer's rm.
50	money rm.
51	unclaimed bag.

MICHIGAN CENTRAL STATION

01 elevator lobby
02 stairs
03 boiler flute
04 open to below
05 open office space
06 roof

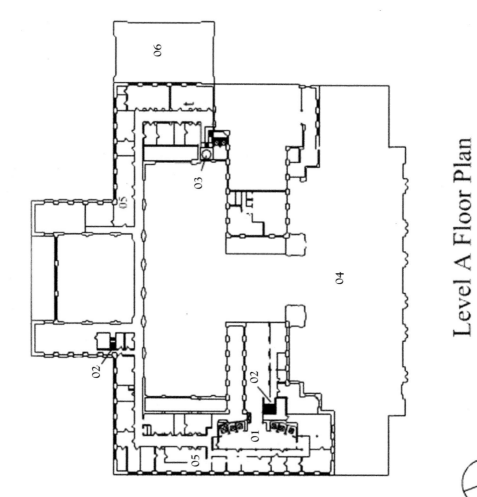

Level A Floor Plan

n.t.s

drawn by DRL

MICHIGAN CENTRAL STATION

01 elevator lobby
02 stairs
03 boiler flute
04 open to below
05 open office space
06 roof
07 bathroom

drawn by DRL

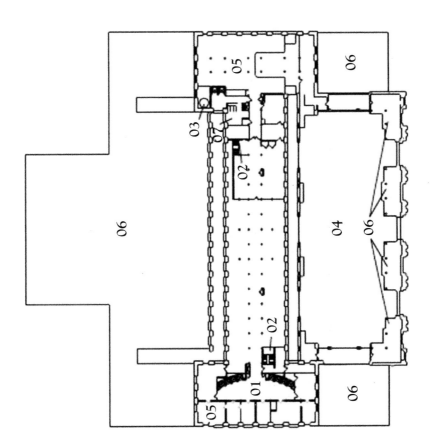

Level B Floor Plan

n.t.s

N

MICHIGAN CENTRAL STATION

01 elevator lobby
02 stairs
03 boiler flute
04 open to below
05 open office space

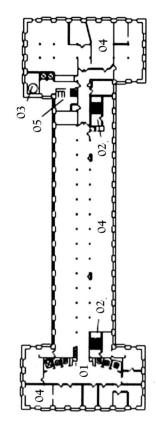

Upper Floor Plan (typ.)

n.t.s

drawn by DRL

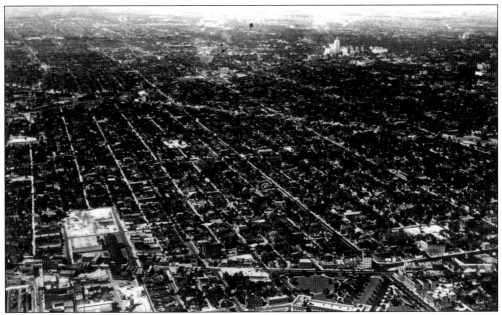

A close-up aerial photograph from the early 1930s reveals the symmetry inherent in the walkway design of Roosevelt Park. In the distance, the golden tower of the Fisher Building marks the New Center area, where Detroit's remaining Amtrak train station can now be found. (Courtesy of the Burton Historical Collection)

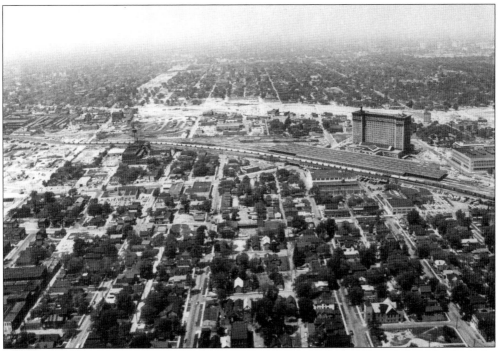

Taken in 1968, this view from the south puts into perspective the startling scale with which the station relates to its primarily residential neighbors. (City of Detroit Department of Public Information, courtesy of the Burton Historical Collection)

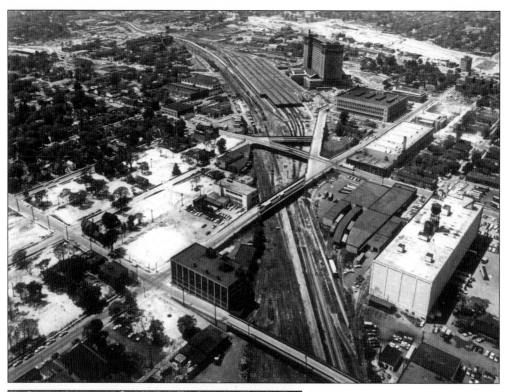

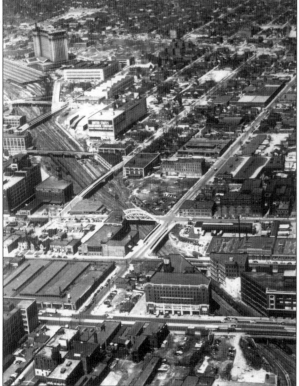

This 1968 aerial looks northwest. The train tunnel portal is just south of Porter Street, the road at the bottom of the picture. (City of Detroit Department of Public Information, courtesy of the Burton Historical Collection)

Also facing northwest, this photograph makes it clear that incoming trains from Canada were not required to make street crossings. This great convenience for trains is a major reason the station was situated in this manner. (Courtesy of the Burton Historical Collection)

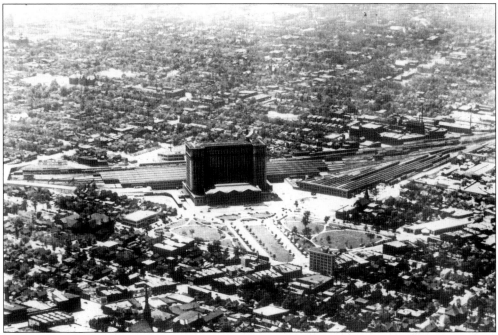

The church visible at the bottom left of this photograph is St. Boniface, which was demolished in 1996, in large part to create more space for Tiger Stadium parking. For many years, empty lots were seen as more valuable than the simple Irish cottages of Detroit's oldest remaining neighborhood, Corktown. (Courtesy of the Burton Historical Collection)

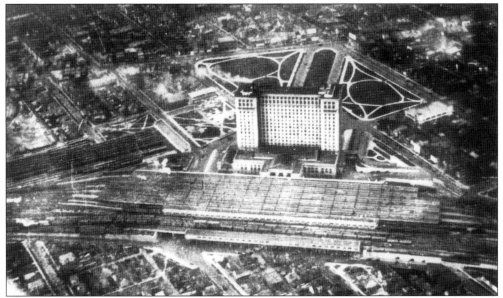

The train sheds, situated behind the Michigan Central, were dismantled in 2000 to facilitate the use of the parcel immediately west of the station as a temporary intermodal facility for the Canadian Pacific Railway. Intermodal facilities allow the transfer of goods from trucks to trains. In some ways then, the depot continues to serve some of its original function despite its current state of vacancy. (Courtesy of the Burton Historical Collection)

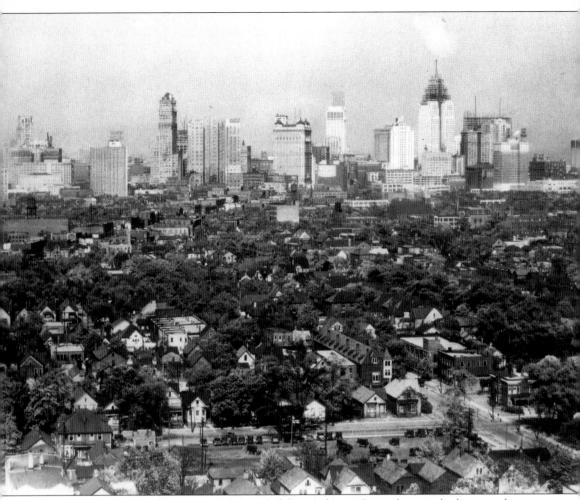

Imagine standing on the corner of the roof of the Michigan Central tower, looking southeast. You would see much the same scene today, albeit a few less homes and trees. By 1928, much of what remains today of Detroit's Central Business District (CBD) was firmly in place, never expanding west through the residential neighborhood of Corktown to the station, as was once envisioned. The 2.25-mile distance between the station and the CBD had much to do with the ultimate downfall of the Michigan Central. (Courtesy of Manning Brothers Historic Photographic Collection)

Three
EXTERIOR AND ENVIRONS

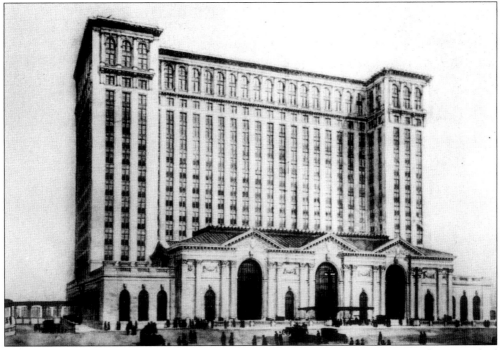

This 1911 rendering of the then-proposed new Michigan Central Depot must have sparked great excitement and civic pride amongst Detroiters. (*Detroit News*, courtesy of the Burton Historical Collection)

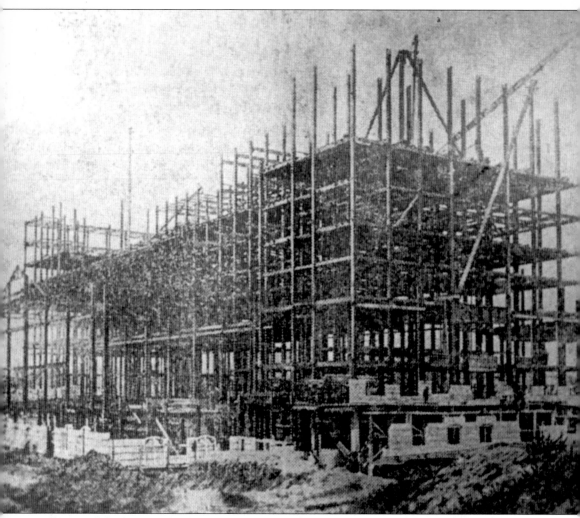

The Detroit Free Press published this photo on November 3, 1912, just over six months after the building contract was signed. It shows the structural steel framing of the Michigan Central in progress. (Courtesy of the Burton Historical Collection)

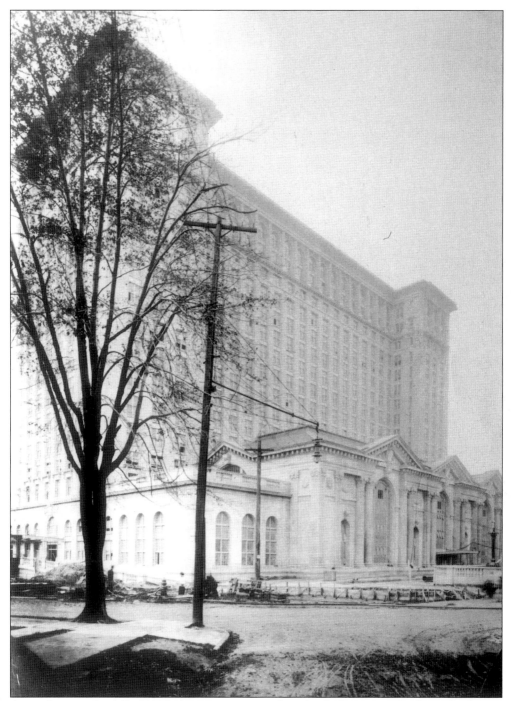

A year later, in the fall of 1913, there is a serious rush to finish the station. Looking closely, you will see temporary power cables, a ladder gingerly leaning against the marquis, and concrete forms yet to be removed from the esplanade. (Courtesy of the Burton Historical Collection)

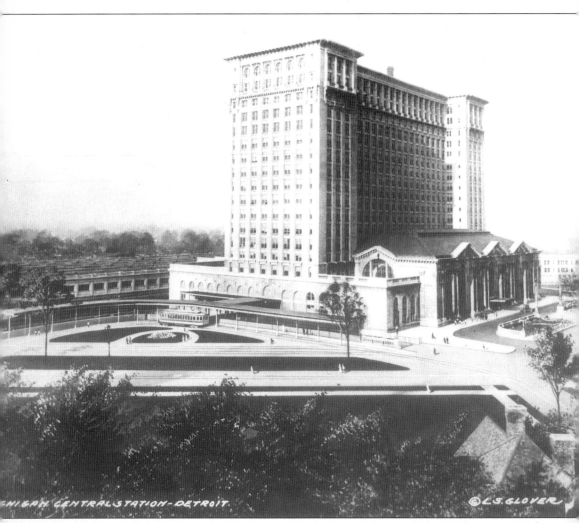

MICHIGAN CENTRAL STATION-DETROIT. ©L.S.GLOVER

This early rendering of the station became a popular postcard image. The Michigan Central Station clearly exemplified the 19th-century Beaux Art ideal of a grand structure in a grand setting. (Courtesy of the Burton Historical Collection)

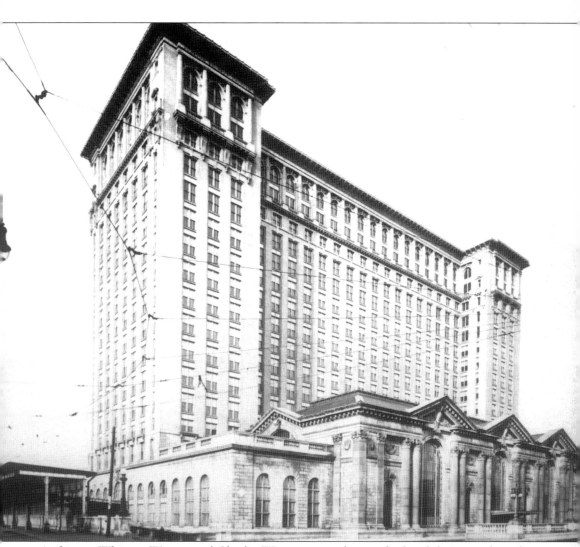

Architects Whitney Warren and Charles Wetmore were known for hotel design, such as the Ritz-Carlton in New York City. The appearance of the Michigan Central's tower, here shown c. 1914–15, certainly belies their roots. In fact, early depot employees believed that the railroad company proclaimed the tower to be office space when they actually planned its future use as a hotel. It is rumored that each floor of the tower had vacuum outlets for this very reason. (Courtesy of Manning Brothers Historical Photographic Collection)

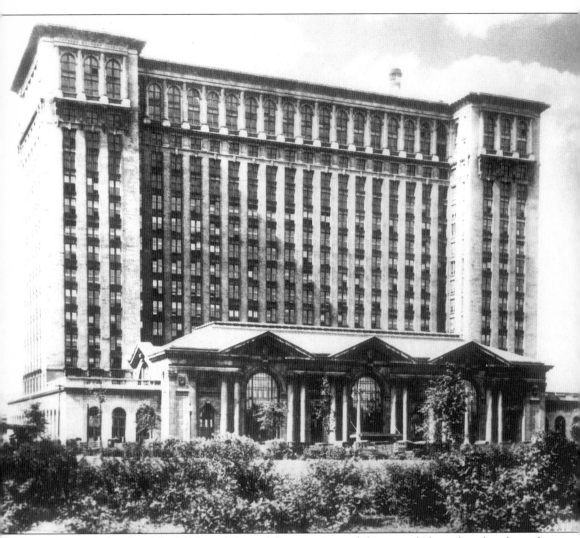

The north façade of the Michigan Central Station received direct sunlight only a few days of the year. The diagonal shadowing visible in this photograph was the unfortunate side effect, generally presenting much of the architectural detail to less than its full potential. (Courtesy of Manning Brothers Historic Photographic Collection)

This circular clipping was printed in the *New-Tribune* on October 31, 1915. (Courtesy of the Burton Historical Collection)

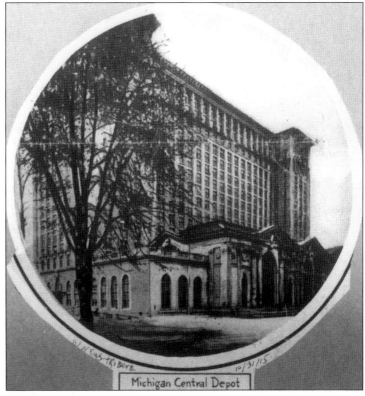

Michigan Central Depot

In 1919, although the station itself functioned as a complete structure, the site development necessary to attain the Beaux Art ideal remained incomplete, as evidenced by the barren landscape in this photograph. (Courtesy of the Burton Historical Collection)

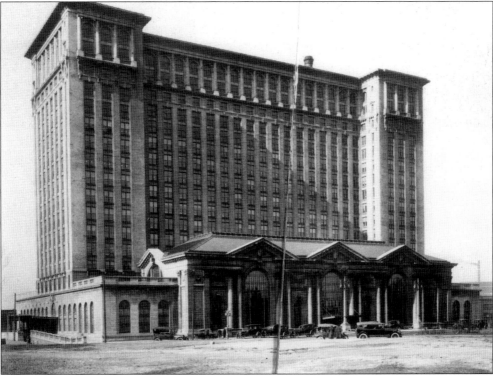

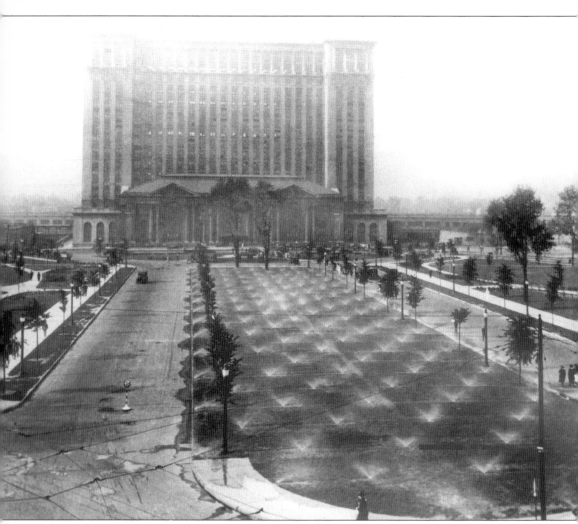

By the time this 1921 photograph was taken, the aforementioned ideal had been reached. The unique road configuration leading up to the Michigan Central, as well as the fine ambiance Roosevelt Park contributed to the scene, reveals itself to be absolutely necessary to complete the designers' vision. (Courtesy of Manning Brothers Historical Photographic Collection)

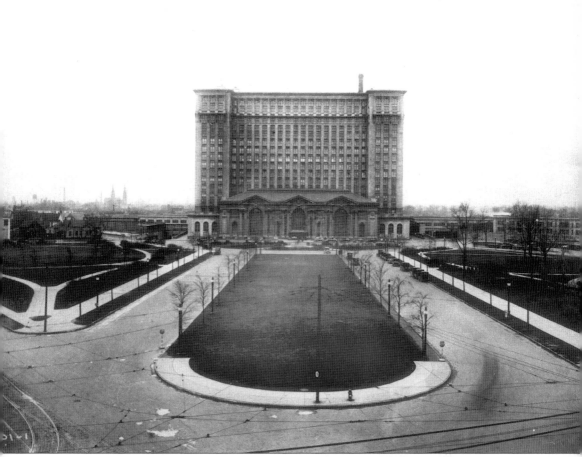

The land necessary to complete Roosevelt Park was not fully acquired until 1918, in great part due to lawsuits from homeowners who were displaced when condemnation proceedings began. The park, named for former President Theodore Roosevelt, was completed in 1922 with a final cost to the city nearing $700,000.

One aspect of Beaux Art architecture that was often found to be a fault was its obvious focus on form over function, or aesthetics over more practical matters. Roosevelt Park, although inarguably grand, would not have been immune to such complaints. (Courtesy of the Burton Historical Collection)

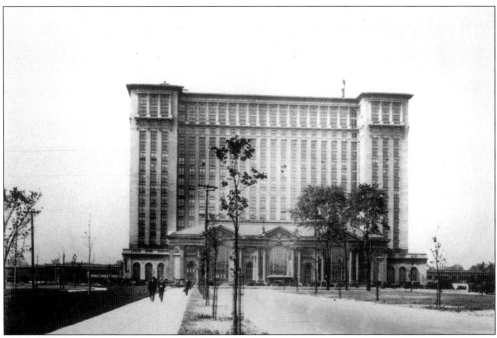

The pedestrian approaching or leaving the monumental station is quite dwarfed by its massive façade. (Courtesy of the Burton Historical Collection)

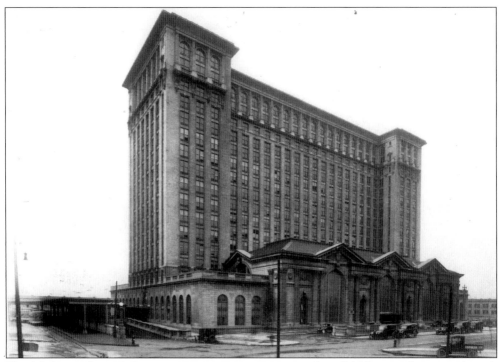

The Michigan Central Station proper contains an astounding 7,000 tons of structural steel, 125,000 cubic feet of stone, and seven million common bricks. (Courtesy of the Burton Historical Collection)

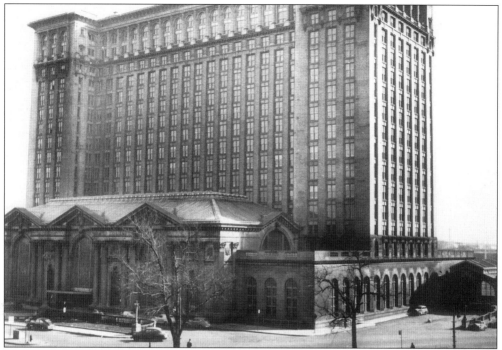

The building is 345 feet across its front and 266 feet deep. The total height of the station is 230 feet, with 98 of those feet being the height of the main portion of the building, consisting of the main waiting room and its auxiliary facilities. (Courtesy of the Burton Historical Collection)

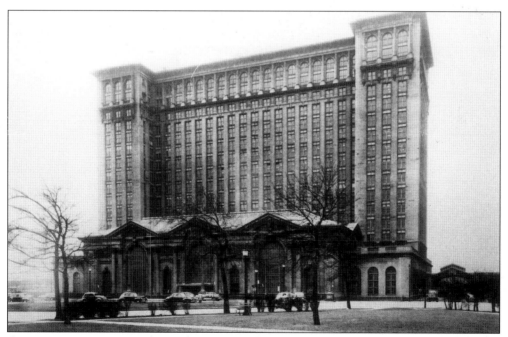

A massive marquis covers the Michigan Central's main entrance. Above the door and to each side are three large arched windows measuring 21 feet by 40. Two smaller arched windows, sized 8 feet by 20, immediately frame the door. (Courtesy of the Burton Historical Collection)

Looking directly at the Station's east façade reveals the streetcar terminal—and the associated overhead wiring. (Courtesy of the Burton Historical Collection)

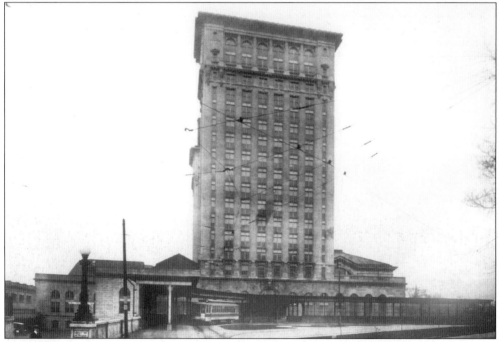

Some things never change. The two coaches to the left of this photograph were situated on spurs used by "important" people who could thus exit their train without walking through the station proper. An oft-repeated tale relates the simultaneous arrival of Charlie Chaplin and then United States Cabinet member Herbert Hoover sometime after World War I. Hoover was literally unnoticed as Chaplin was mobbed by adoring fans. (Courtesy of Manning Brothers Historic Photographic Collection)

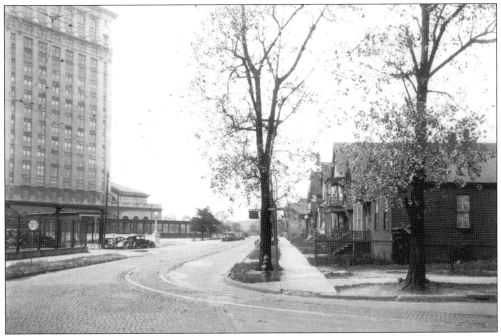

This 1932 photo looks north on Fourteenth Street, just east of the station. The wood-frame homes, common to the Corktown neighborhood, visibly attest to the residential setting of the station. South and west of the Michigan Central, light industrial uses were also mixed in with the homes and neighborhood businesses comprising the Mexicantown community. (Courtesy of Manning Brothers Historic Photographic Collection)

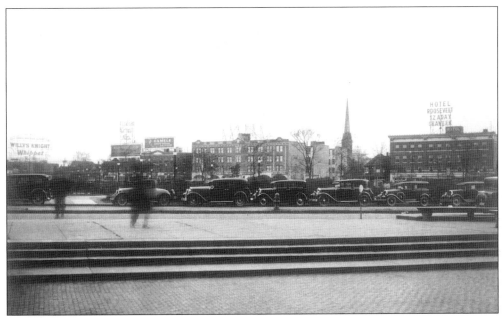

The Roosevelt Hotel beckoned visitors to rest their weary heads. Travelers looking for more luxurious accommodations were forced to taxi downtown to such establishments as the Book-Cadillac or the Statler. (Courtesy of Manning Brother Historic Photographic Collection)

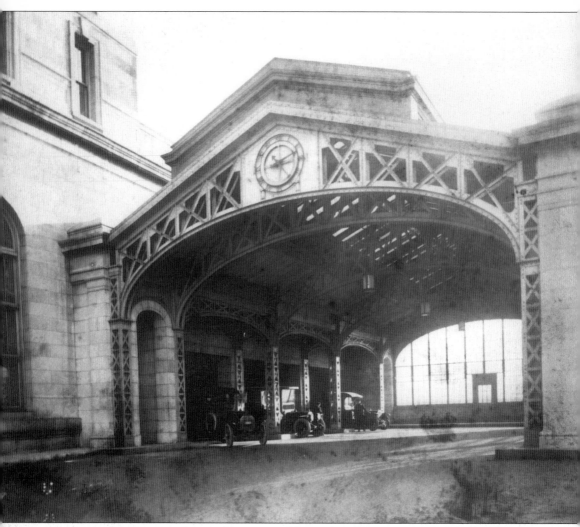

Cabs waited for a paying fare in the taxi stand located at the western end of the building. The original architectural drawings of the station refer to this area as a "carriage entrance," which illustrates the designers' lack of faith in the certainty of growth in the automobile industry. (Courtesy of the Burton Historical Collection)

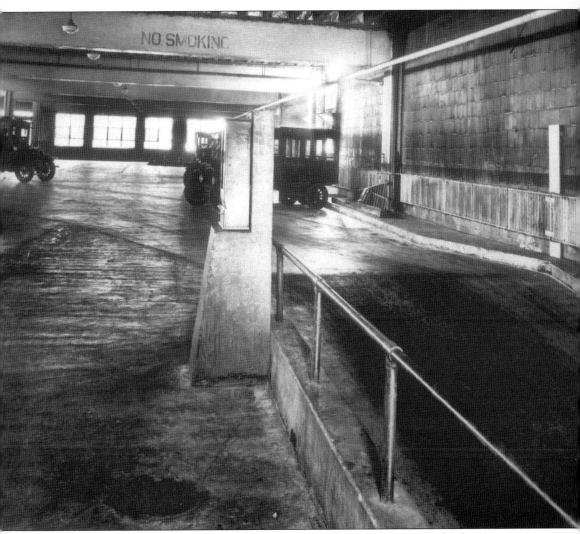

Unlike today's development plans, which discuss parking lots and structures ad infinitum, one level of underground parking was all the Michigan Central's designers saw necessary to construct. (Courtesy of the Burton Historical Collection)

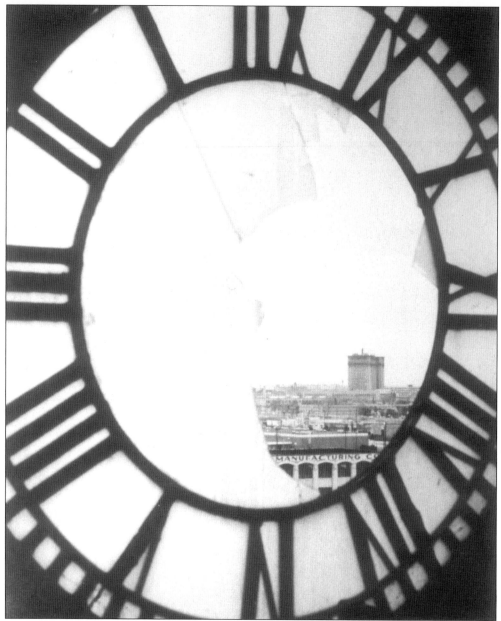

There is undoubtedly a dark premonition permeating this print, which was taken in 1974, before the Michigan Central had yet to finally cease operation. This haunting image views the station in the distance through a broken clock face of the Fort Union Station, which was to be demolished later that same year. (Garnet Cousins, courtesy of the Burton Historical Collection)

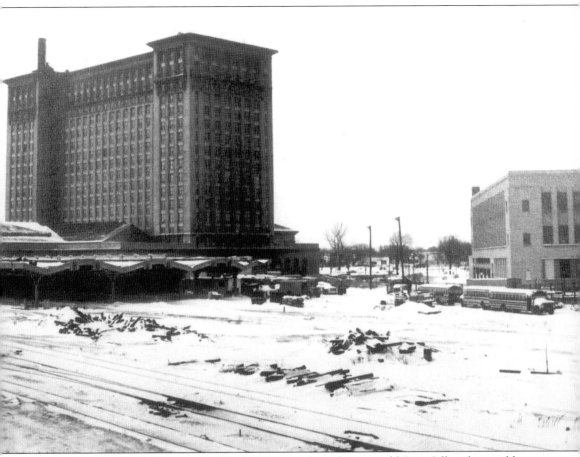

This 1978 photograph faces north. The building to the right is an old Post Office designed by Detroit's own Albert Kahn. A later use for the structure was as a book depository for the Detroit Public Schools, which may explain the school buses parked nearby. (Garnet Cousins, Courtesy of the Burton Historical Collection)

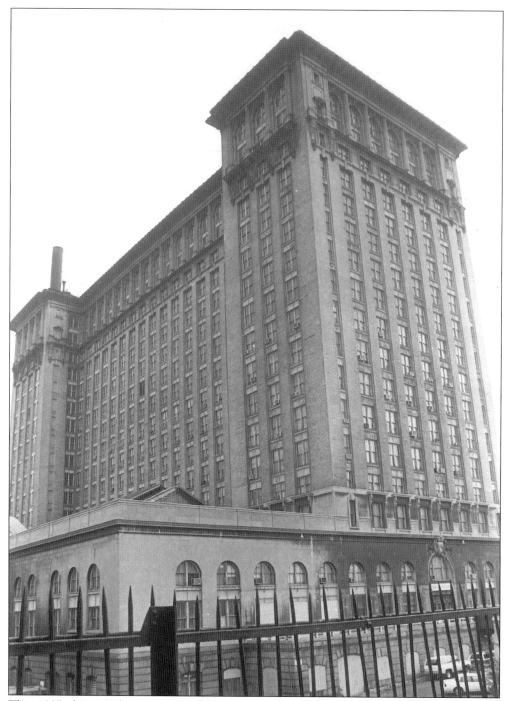

This 1987 photograph, near the end of the station's run, seems as if it could come from an earlier era—until the window air-conditioning units are noticed. Some entranceways are visibly boarded up, and the taxi stand has been re-commissioned as guest parking. (Allan Barnes)

Four

INTERIOR

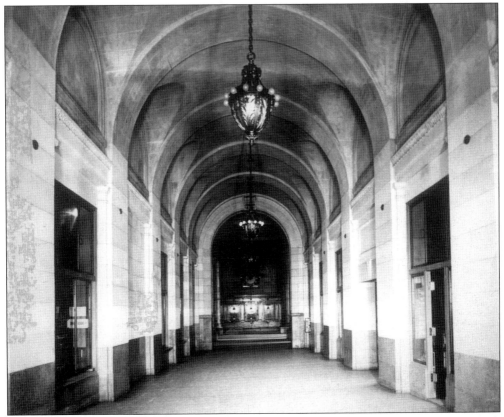

A stroll down this glorious arcade leads to the ticket office. Ceiling heights, reaching upwards of 28 feet, would alter a simple walk into a procession of some dignity. Structures such as the Michigan Central Station communicate a level of respect from architects and engineers to the general populace—something quite difficult to conceive of in an era of disposable buildings that instead tend to whisper, "do not linger—there is nothing here for you." (Courtesy of the Burton Historical Collection)

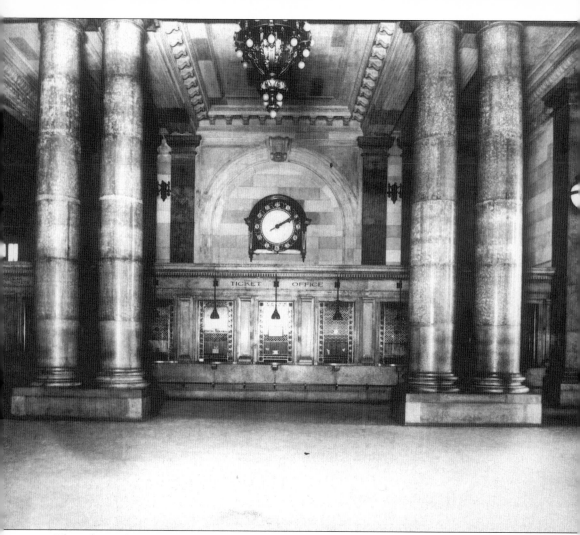

This photo, facing west, gazes upon the ticket windows and lobby. Despite the pleasing appearance of this Michigan Central interior view, some design flaws are hereby revealed. There is a notable lack of signs to guide the traveler, and some of the ticket windows are simply hidden behind the stately, yet quite gargantuan, columns. (Courtesy of Manning Brothers Historic Photographic Collection)

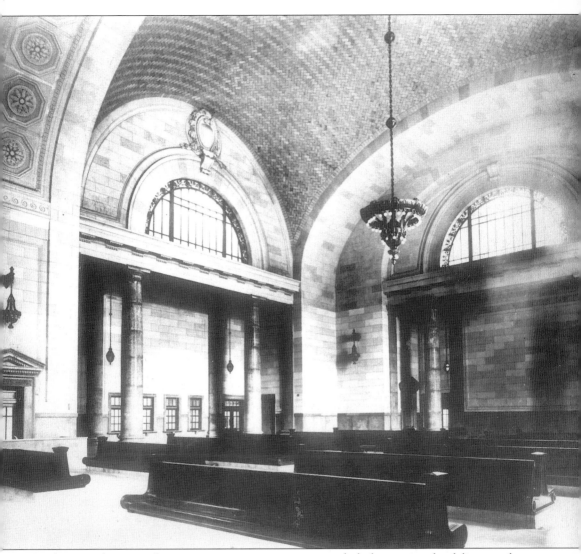

Looking southwest in the main waiting room, one cannot help but notice the delicate arches that create the most prominent architectural detail of the space. These shell constructions of thin tile and strong mortar are known as Guastavino arches, after the Catalan engineer who modernized traditional tile vaulting. (Courtesy of the Burton Historical Collection)

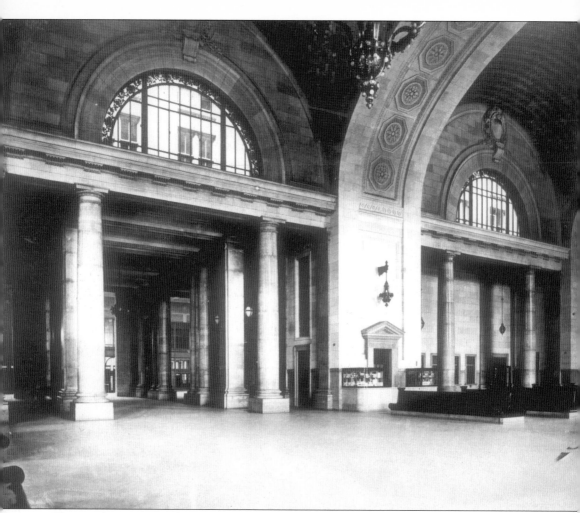

This southeast view of the waiting room, looking towards the ticket office, can only hint at the tactile and visual delight conferred from its Indian mahogany benches, Kasota marble walls and columns, and ceiling height of 54.5 feet. This photograph emanates the echoes of footsteps, announcements, and shouts of greetings. (Courtesy of Manning Brothers Historic Photographic Collection)

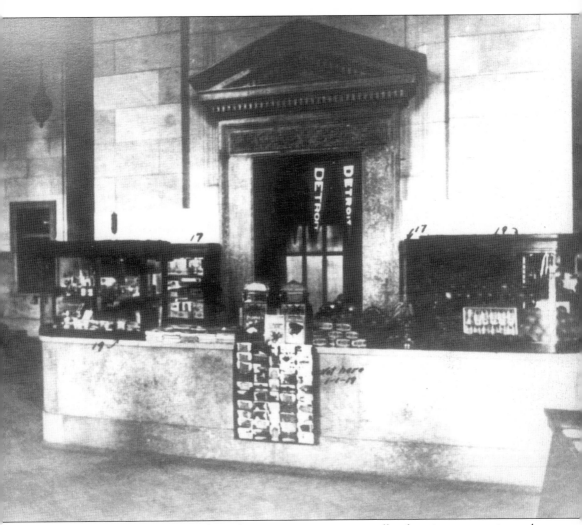

This concession stand, located in the main waiting room, offered various souvenirs and sundries. Who knows how many postcards of the depot were purchased from this very spot and then hastily mailed to families and friends? (Union News Company, Courtesy of the Burton Historical Collection)

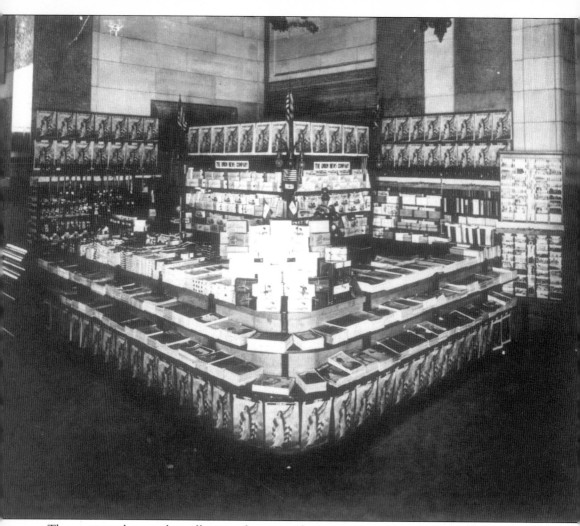

The newsstand catered to all sorts of tastes with a variety of titles: *Short Stories*, *Forest and Stream*, *Munsey*, *The North American Review*, *Baseball*, *Popular Mechanics*, *Detective Story*, and *The Spice Box*. (Union News Company, Courtesy of the Burton Historical Collection)

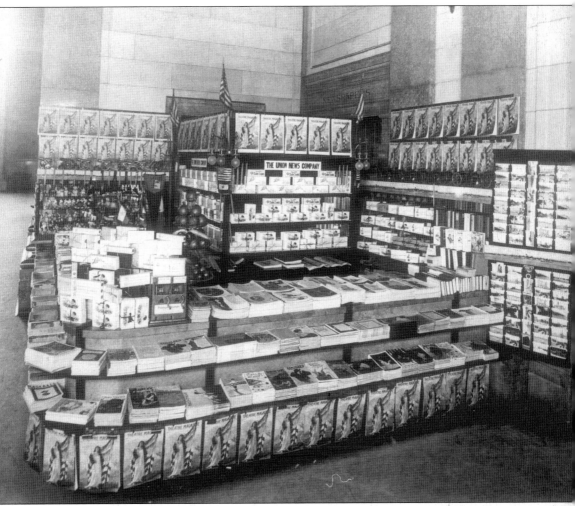

The magazine lining the bottom shelf and back walls of this rather patriotic display is *Theatre Magazine*. One cannot help but wonder if *Theatre* was really such a popular title—or the woman draped in a flag on its cover served to illuminate the Union News Company's national pride. (Union News Company, Courtesy of the Burton Historical Collection)

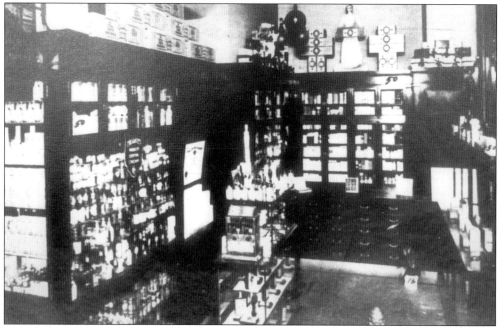

The drugstore, run by Union News of Chicago, boasted two pharmacists. The usual suspects were also close at hand: tooth powder, first aid, photo supplies, and the like. (Union News Company, Courtesy of the Burton Historical Collection)

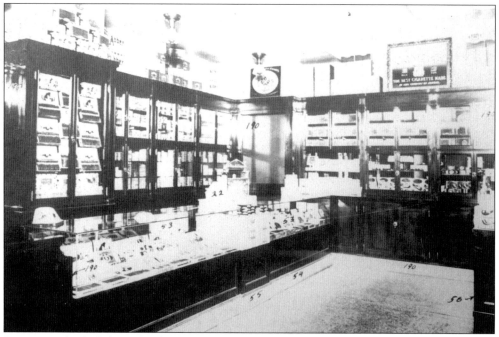

Just across the hall from the drugstore was the cigar shop. The classic wood and glass display cases must have enticed many a gentleman to indulge himself in a fine Cuban before—or during—his impending journey. (Union News Company, Courtesy of the Burton Historical Collection)

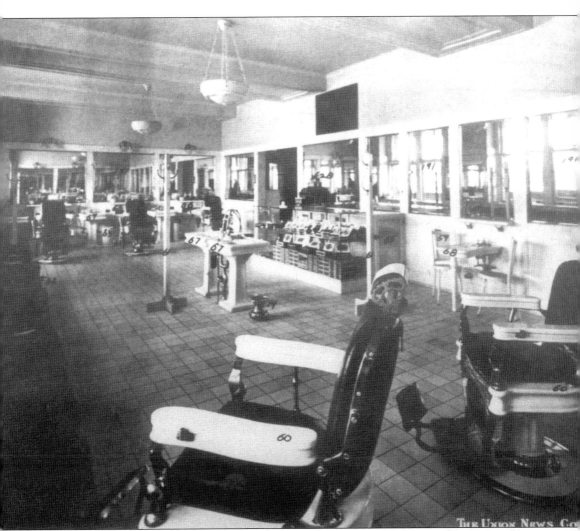

The well-groomed gentleman traveler wishing to look his best upon arrival had the opportunity to receive a quick trim in this barbershop. Through the door towards the back of the space, a bath could be rented for a few pennies. There would be no excuse for returning home in anything less than tip-top shape. (Union News Company, Courtesy of the Burton Historical Collection)

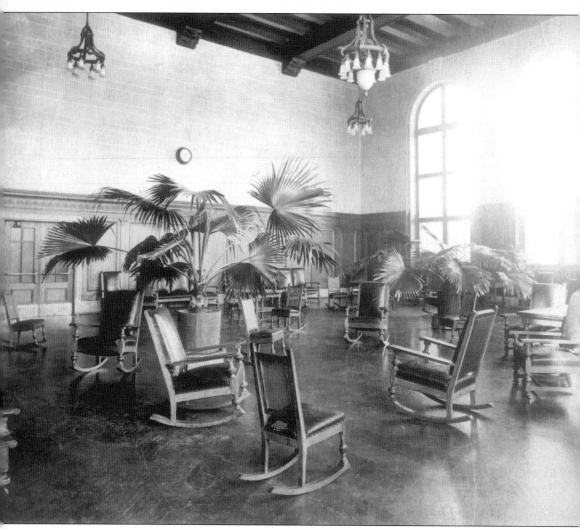

This photograph speaks volumes about the level of comfort awaiting a traveler at the Michigan Central. Leather rocking chairs, shiny wood floors, enormous potted plants, and light-filled arched windows gave the women's room a sense of import and style. (Courtesy of Manning Brothers Historic Photographic Collection)

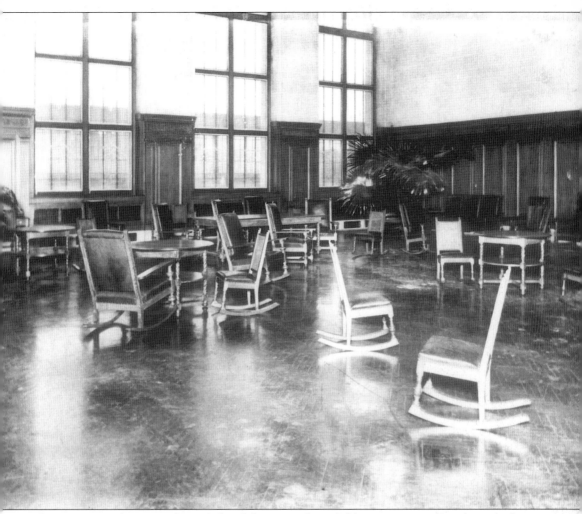

It is quite simple to visualize a lady of the era with coifed hair, a string of pearls, and white gloves, perched expectantly at the edge of her rocking chair. She pages through her *Harper's*, nervously waiting for the 6:15 arrival from Indianapolis to be announced. A room such as this begs to be populated with such stories. (Courtesy of the Burton Historical Collection)

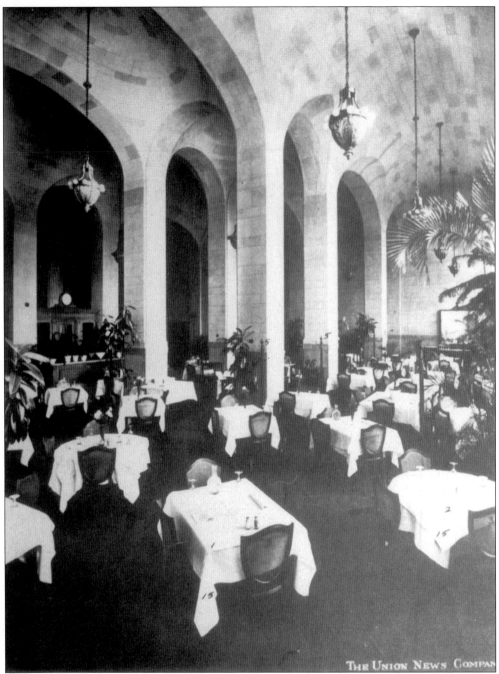

THE UNION NEWS COMPAN

What a dining room! Vaulted ceiling of caen stone, floor of Welsh quarry tile, and tablecloths of the finest linen. Food was prepared in a basement kitchen then brought upstairs by dumbwaiter.

After World War II, part of the dining room was partitioned off to create a kitchen on the first floor. This modernization included the installation of a dropped ceiling, desecrating the eloquent arches. The restaurant was then renamed the *Mercury Room*. (Union News Company, Courtesy of the Burton Historical Collection)

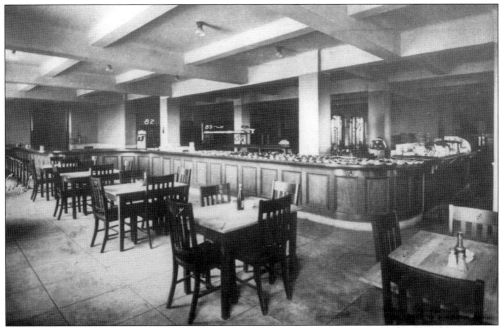

Located directly above the dining room, the employees had their own room in which to grab a quick bite during their break. Food, which was largely self-service, was brought up from the basement in the same manner as to the main dining room. (Union News Company, Courtesy of the Burton Historical Collection)

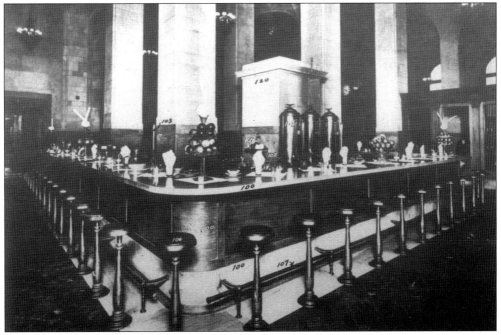

Picture this lunch counter when the station was serving its peak of 5,000 travelers each average day, mobbed by throngs of thirsty travelers dying to be poured a refreshing soda. (Union News Company, Courtesy of the Burton Historical Collection)

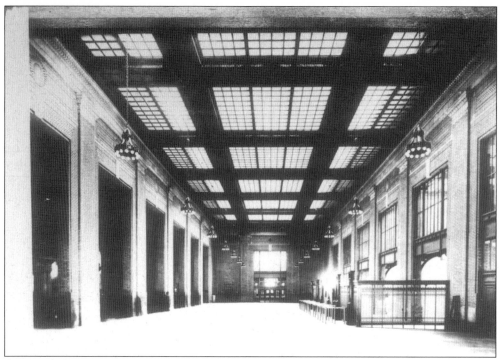

A 1914 photograph of the main concourse practically glows from the great number of skylights in the space. (Courtesy of the Burton Historical Collection)

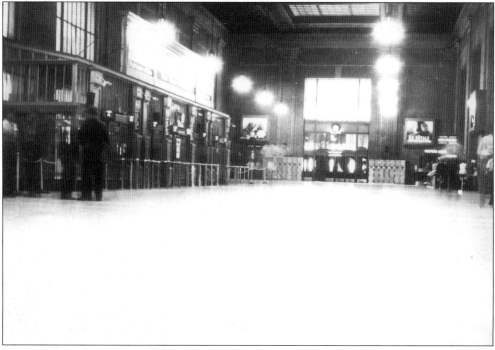

In this 1948 photograph of the same space, there is more signage—and presumably less confusion for the traveler. (Elmer Treloar, Courtesy of the Burton Historical Collection)

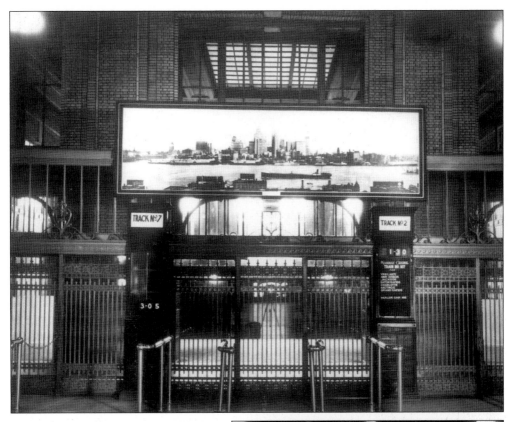

The classic Detroit skyline personalizes the gate for track numbers 2 and 7. Track number 2 announces the 1:30 train to Grand Rapids via Ann Arbor and Jackson. (Courtesy of the Burton Historical Collection)

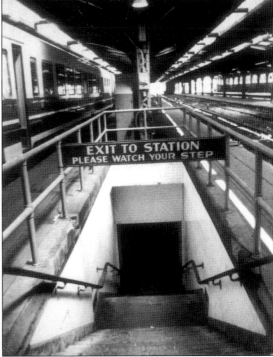

Entering the station from an arriving train, the passenger was guided to a rather utilitarian exit staircase. (Garnet Cousins, Courtesy of the Burton Historical Collection)

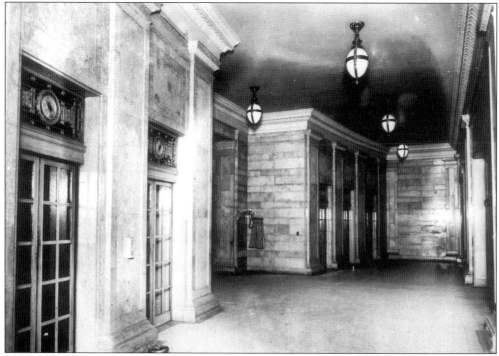

Egg-like light fixtures add a timeless air to the elevator hall found at the east end of the building. (Courtesy of Manning Brothers Historic Photographic Collection)

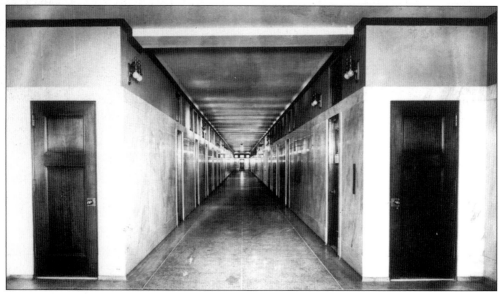

The Michigan Central was constructed with 13 floors of office space, of which five were never wholly completed. This 1916 photograph peers down a main corridor of an upper-level office floor. This stark, ordered, efficient look typified the offices of the period, and was characterized by white marble walls and a terrazzo floor. Invisible in this photograph is another feature of the office hallways: the ubiquitous spittoon. (Courtesy of Manning Brothers Historic Photographic Collection)

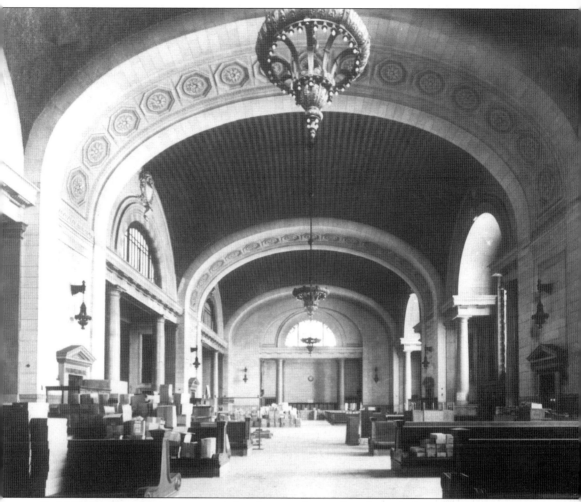

By 1967 the main waiting room was closed to travelers and used merely for storage; it is difficult to conceive of these splendid benches being relegated to use as a mere shelving system. Hanging on by a thread, the Michigan Central continued to operate without its restaurant or even the main park entrance. (Dave Jordano, Courtesy of the Burton Historical Collection)

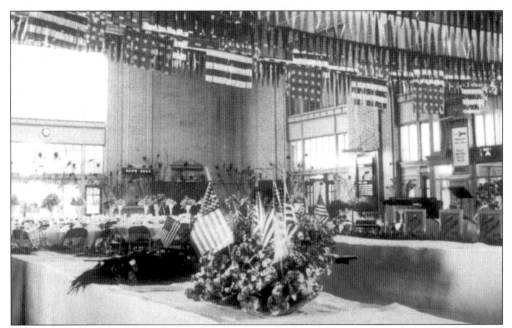

In 1971, Amtrak took over passenger service to and from the Michigan Central, undertaking over $1 million of improvements to the depot, which included the creation of a bus terminal. This photograph depicts the formal reopening of the station on June 20, 1975, the day the "American Freedom Train" arrived in Detroit. (Paul Maximuke, Courtesy of the Burton Historical Collection)

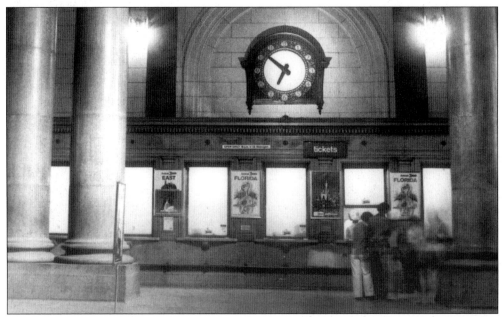

This photo was also taken upon the occasion of the depot's formal reopening. Here, the ticket office has been slightly modernized and made a bit more user-friendly, while retaining the classic elements that formulate its essence. (Paul Maximuke, Courtesy of the Burton Historical Collection)

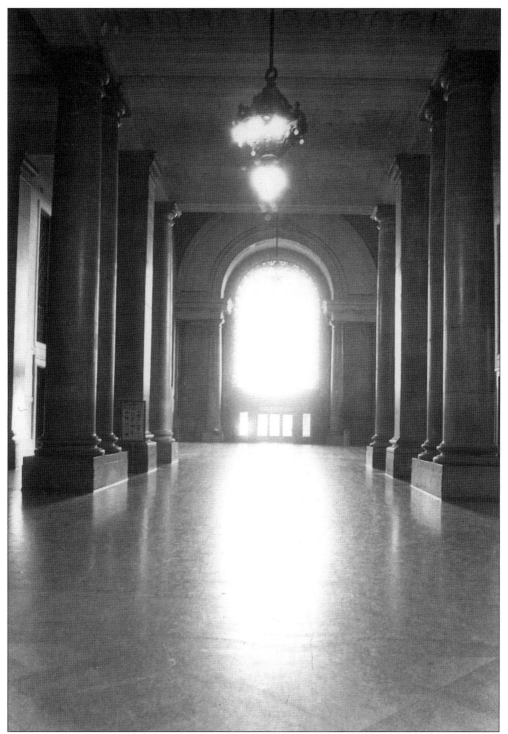

The station, here documented in 1987—just prior to its closure—managed to hold onto its sheen for three-quarters of a century. The thousands of soles that have treaded this waiting room have not yet sullied its grandeur. (Allan Barnes)

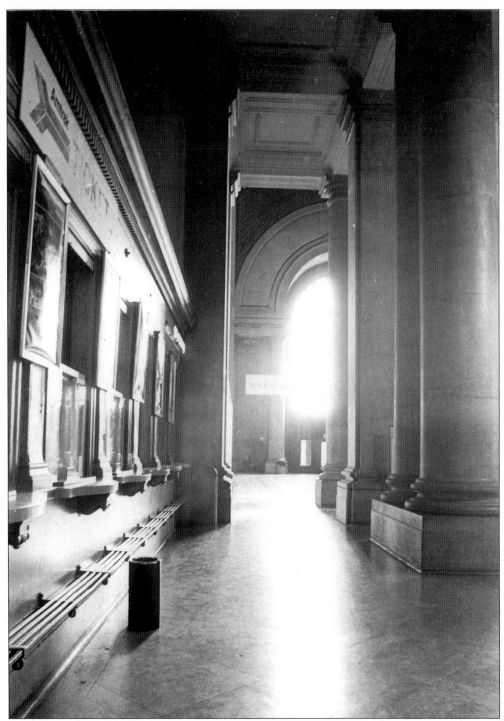

Only a few clues reveal the time frame of this photograph: the wall signage, the Amtrak logo, and the cylindrical aluminum ashtray. It is extremely remarkable that this photo was taken less than 15 years prior to the publishing of this book. A later chapter will display the decay that has occurred since this closure, which took place on January 5, 1988. (Allan Barnes)

Five

PEOPLE

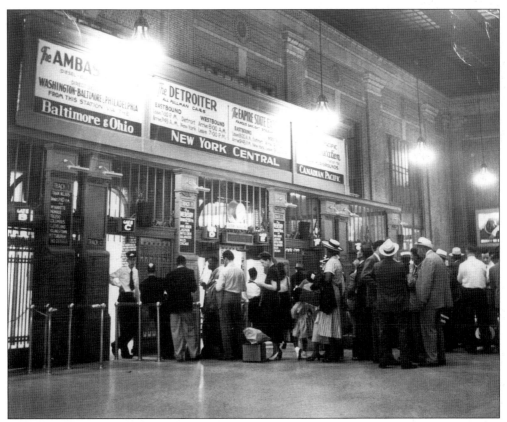

These patient folks, tickets in hand, await the arrival of their luxurious Mercury train, advertised as the "Train of Tomorrow." (Norman Hammerl, courtesy Burton Historical Collection)

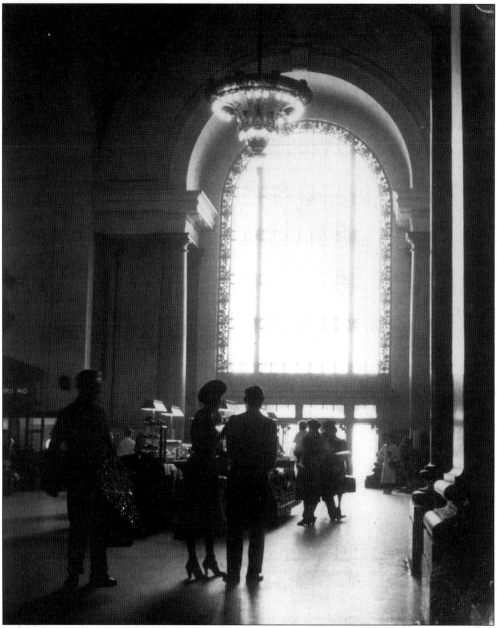

The beautiful lighting effect this 1949 photograph imparts mirrors the glorious World War II era in Detroit. Automobile purchases and wartime production turned Detroit into a boomtown. The opulence of the Michigan Central Station seems appropriately regal for the city then regarded as America's "Arsenal of Democracy." (Norman Hammerl, Courtesy Burton Historical Collection)

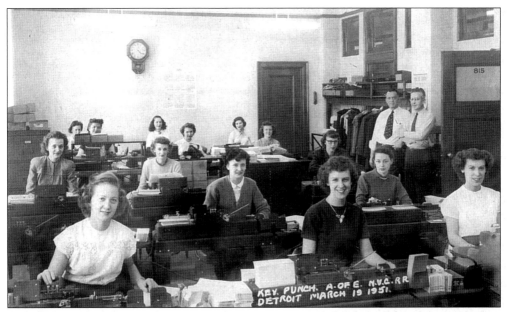

The office tower of the Michigan Central Train Station was the daily place of work for many people. This photograph depicts IBM Key Punchers and Verifiers of the New York Central Railroad Company's Auditor of Expenditures Department. Dorothy Lewis Delphy, seated in the middle of the front row, worked as an IBM Key Puncher from 1950 through 1960; her sister, Gloria Lewis Tabone, seated to her left, worked at the depot for 22 years. (Courtesy of Dorothy Delphy)

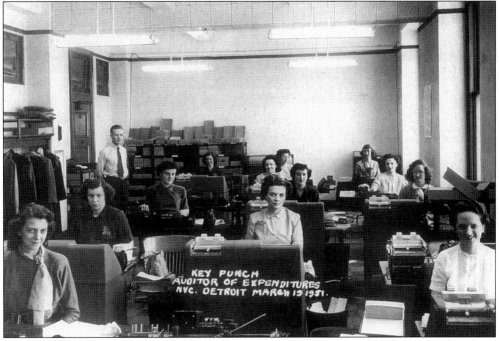

The Auditor of Expenditures Department occupied the entire eighth floor of the Michigan Central. Lead operator Alice Ratcliff is seated in the lower right corner of this photograph; supervisor Harold Bennett stands near the door. (Courtesy of Dorothy Delphy)

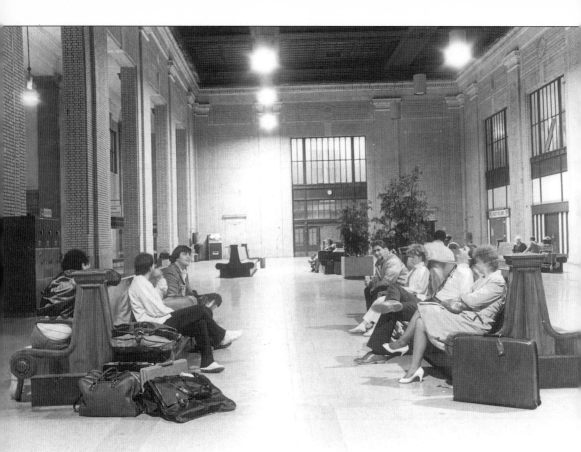

In 1985, the then-owner of the Michigan Central, William Spencer, chairman of the Kaybee Corporation, pumped a million dollars into a substantial clean-up of the station. This 1987 photograph reflects the success of that effort—the concourse certainly appears to be holding up quite well. (Allan Barnes)

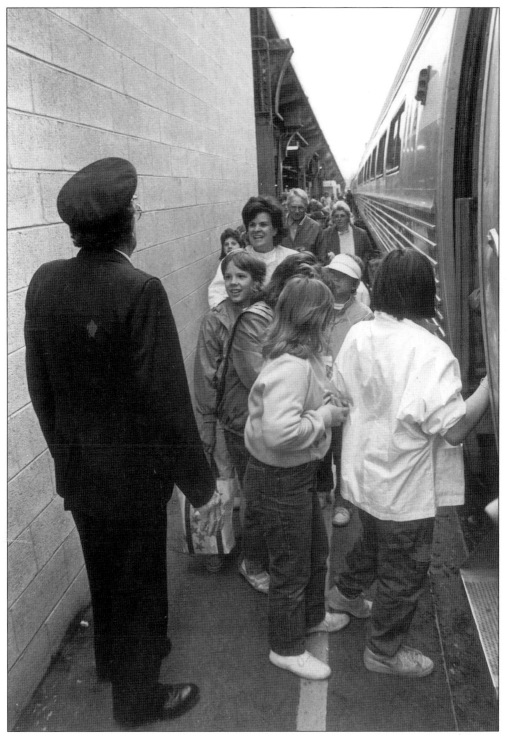

This series of photographs, including the previous image, was taken to illustrate an article about the impending closure of the Michigan Central Station to passenger travel. Many were then published in Wayne State University's student newspaper, *The South End*. (Allan Barnes)

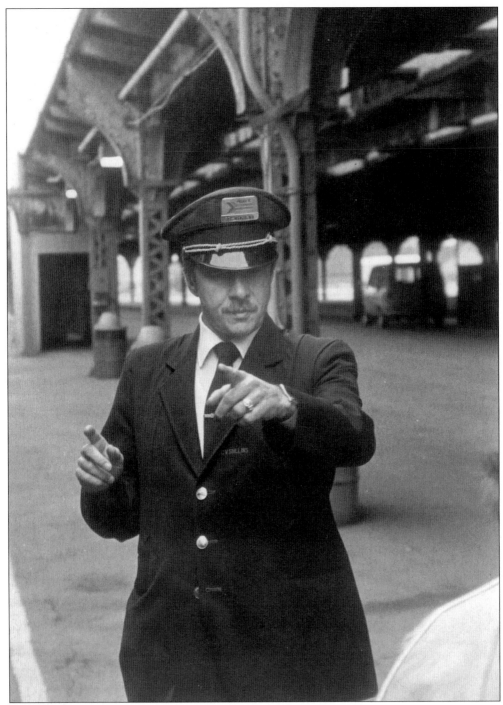

All aboard! This train attendant guides expectant passengers to their proper car. It would be interesting to know if passengers were aware that this would most likely be their final opportunity to board a train from the venerable Michigan Central Station. It seems that this knowledge would have lent a certain gravity to this particular December 1997 journey. (Allan Barnes)

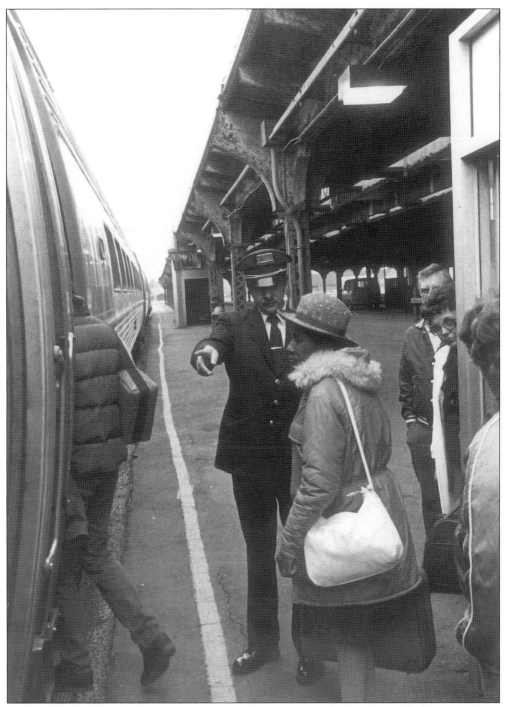

The series of improvements made to the Michigan Central throughout the years was not sufficient to reverse a continuing decline in passengers. This loss of ridership can be attributed to several reasons, including the station's isolation brought on by the demise of Detroit's trolley system, an increase in the popularity of air and personal automobile travel, and Detroit's population decline. (Allan Barnes)

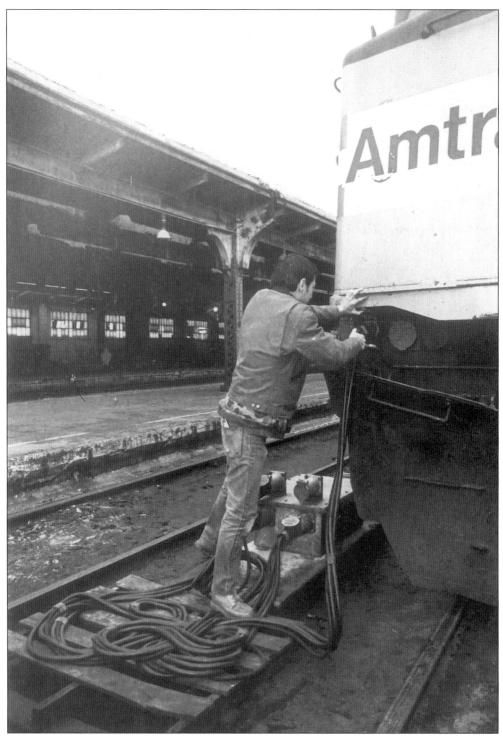

Business as usual: while passengers boarded the train, it was refueled, (Allan Barnes)

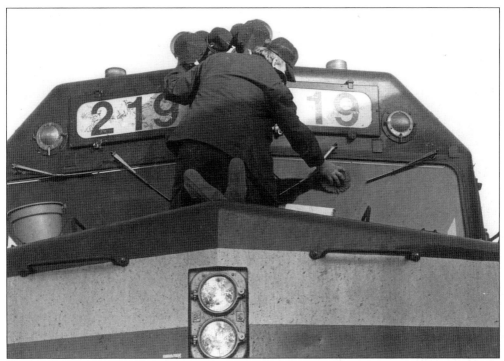

the windows were washed, (Allan Barnes)

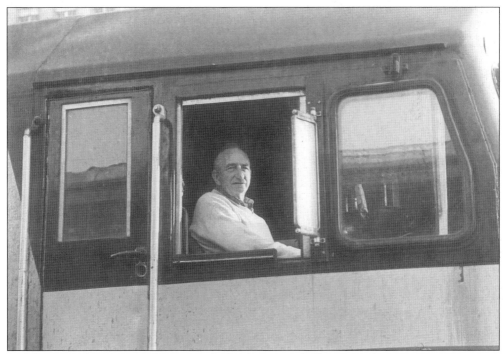

and the Amtrak crew waited expectantly for departure. (Allan Barnes)

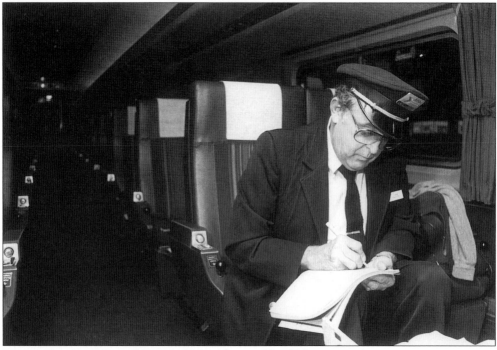

The conductor goes over his notes before the car fills. (Allan Barnes)

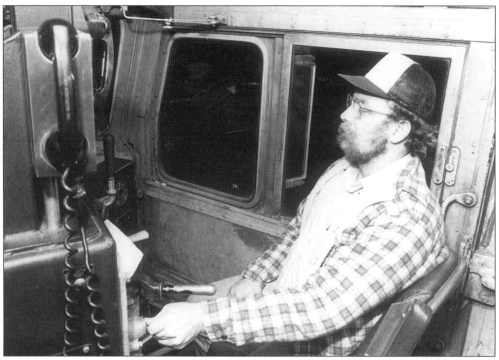

Engineers operate trains, and this one certainly seems ready to do so. January 5, 1988, was the last opportunity one had to pull his or her train away from the Michigan Central Station. (Allan Barnes)

Six

TRAINS

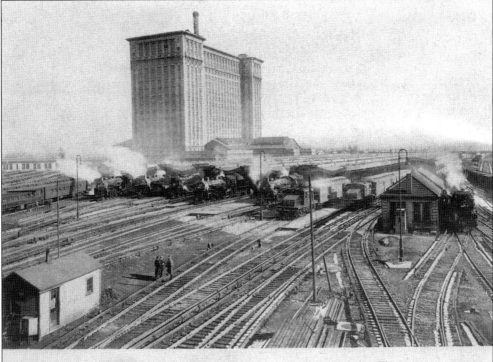

Michigan Central Terminal — A Gateway of the City

This photograph was published in *The Detroiter* on December 21, 1925. It views the entire Michigan Central site northeasterly, and was taken from the roof of the electric engine inspector shed. (Courtesy of the Burton Historical Collection)

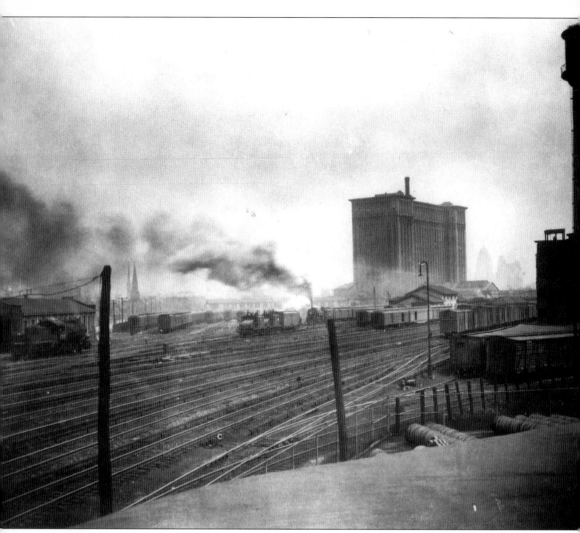

In this photograph, trains are beginning their journeys to the west. Who knows the lovers separated, the journeys begun, at this particular point in time? (Courtesy of the Burton Historical Collection)

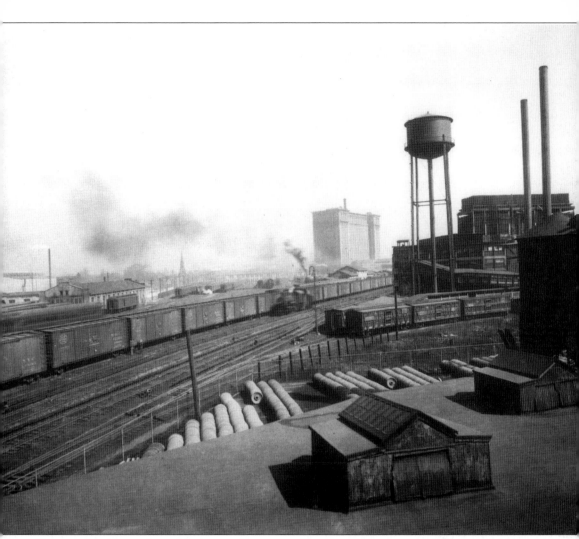

Once again, the coach yard is shown above tops of boxcars. A passenger train is just visible to the far left of the photograph, nearly obscured by a freight train. (Courtesy of the Burton Historical Collection)

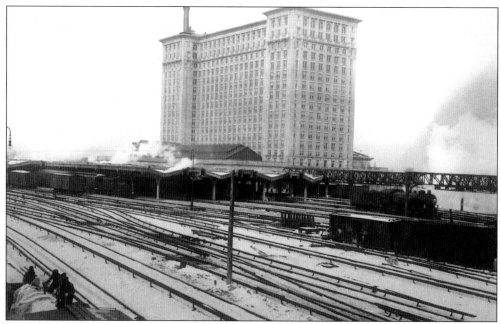

This photograph was taken on March 12, 1926. Passengers arriving at the Michigan Central would disembark their train onto platforms measuring 19 feet wide, in the centers of which were stairways leading to a passageway running beneath the train shed. A grade of about 7 percent was used for this tunnel that led to the concourse, on account of the difference in level between the street and the tracks. (Courtesy of the Burton Historical Collection)

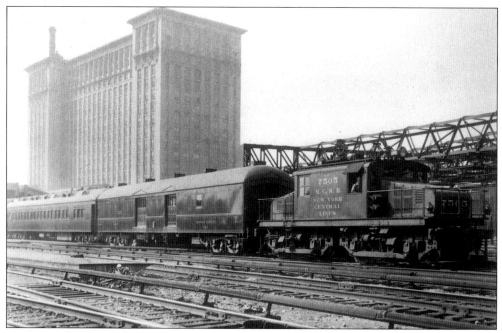

Customs offices were housed along the east side of the underground passageway, which measured 40 feet wide and 8 feet high. The Immigration Bureau and detention rooms were located directly beneath. (Courtesy of the Burton Historical Collection)

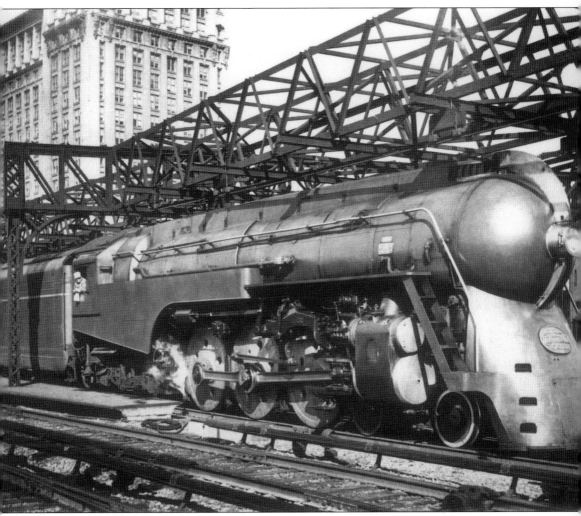

On October 17, 1939, this *Mercury* train arrived at the Michigan Central Station from Chicago; it is shown stopped at the east end of the train shed. (Ed Nowak, courtesy of the Burton Historical Collection)

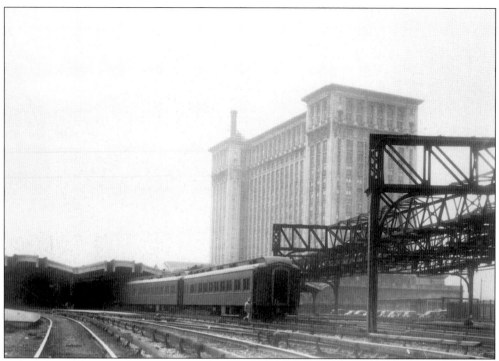

This train, waiting on track seven, was photographed from Fifteenth Street looking northwest. (Courtesy of the Burton Historical Collection)

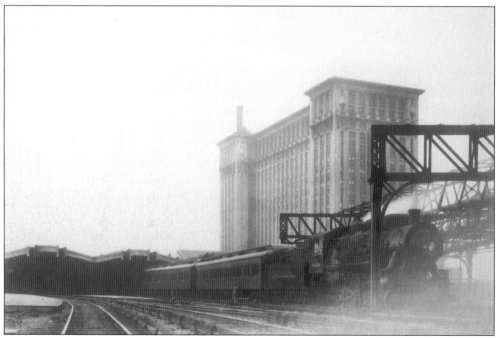

Looking northwest, this train is also viewed from Fifteenth Street. The train shed covered 11 tracks, and an additional seven were dedicated to freight traffic. (Courtesy of the Burton Historical Collection)

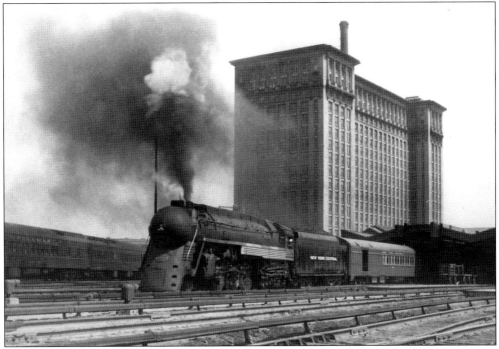

At 12:50 p.m. on April 20, 1948, New York Central locomotive number 5429 pulled *Mercury* train number 75 westbound for Chicago. The third rail, which parallels all tracks, was used by the electric locomotives that moved all Canadian Pacific Railroad and New York Central trains through the Detroit River Tunnel. (Elmer Treloar, Courtesy of the Burton Historical Collection)

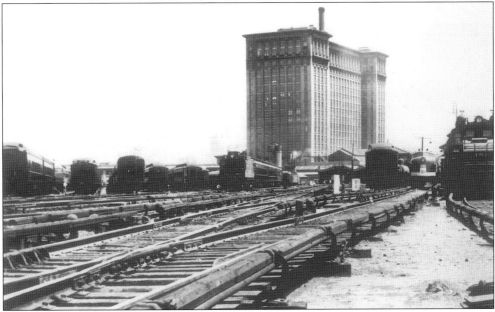

This June 5, 1948 photograph documents both a Pullman and an electric locomotive in the coach yard. In addition, two more locomotives sit on the freight tracks. (Elmer Treloar, Courtesy of the Burton Historical Collection)

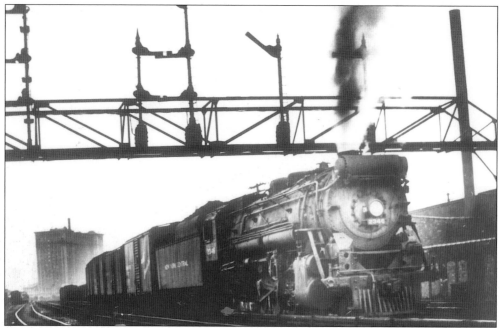

This picture was taken from about 22nd Street on July 12, 1948. This scene looks toward the northwest, with freight being pulled by Mikado. (Elmer Treloar, Courtesy of the Burton Historical Collection)

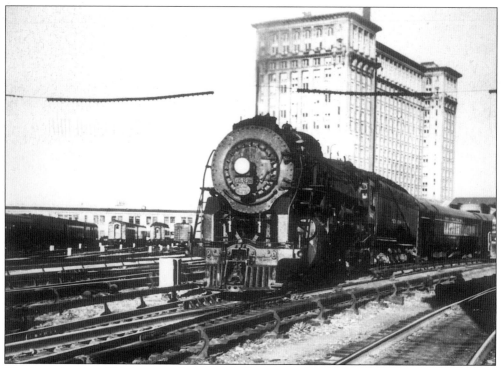

Westbound train #321 is set to depart at 5:35 p.m. on September 7, 1953. (Elmer Treloar, Courtesy of the Burton Historical Collection)

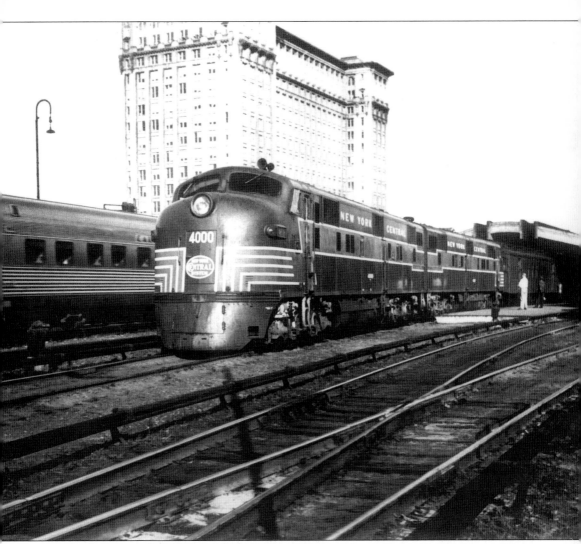

A New York Central *Twilight Limited* is pictured pulling the *California Zephyr* sleeper. These westbound trains were photographed at 4:45 p.m. on September 7, 1953. (Elmer Treloar, courtesy of the Burton Historical Collection)

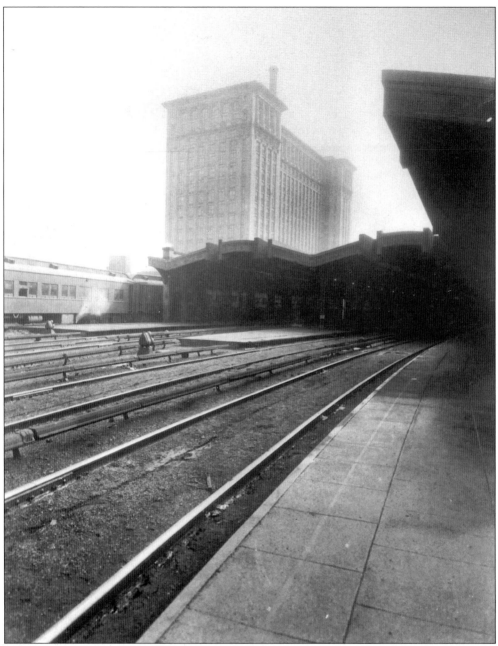

The contributions of George H. Webb, chief engineer for the construction of the Michigan Central Station, were essential to its successful operation. All trackwork, utilities, sheds, and other accessory buildings were under his purview. (Courtesy of the Burton Historical Collection)

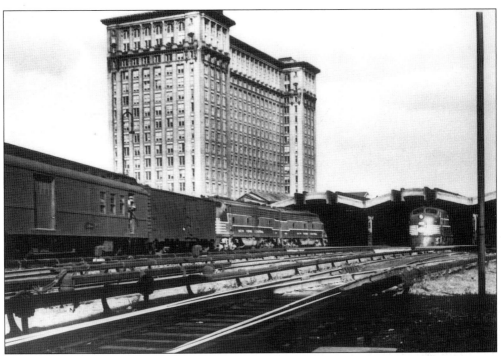

In from Chicago, New York Central train #44 arrived at 4:50 p.m. on September 7, 1953. The *Twilight Limited* (from page 79) is in the stall at the right. (Elmer Treloar, courtesy of the Burton Historical Collection)

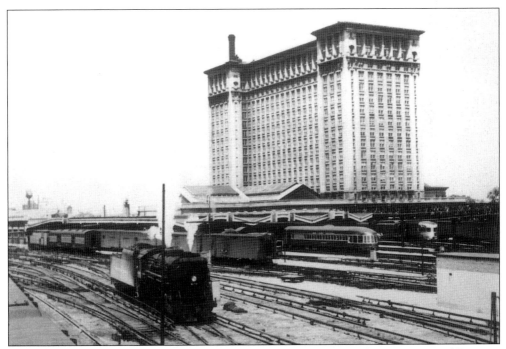

This image, as well as those seen on the following five pages, remembers trains past. (Courtesy of the Burton Historical Collection)

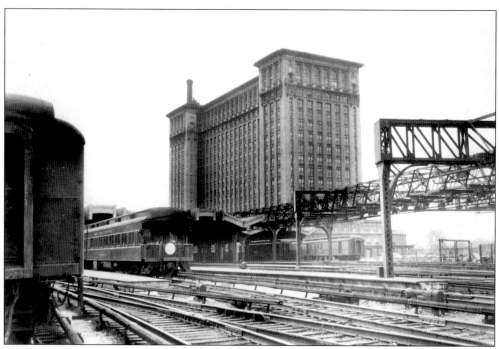

(Courtesy of the Burton Historical Collection)

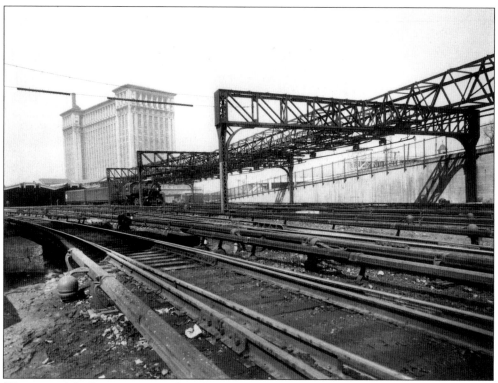

(Courtesy of the Burton Historical Collection)

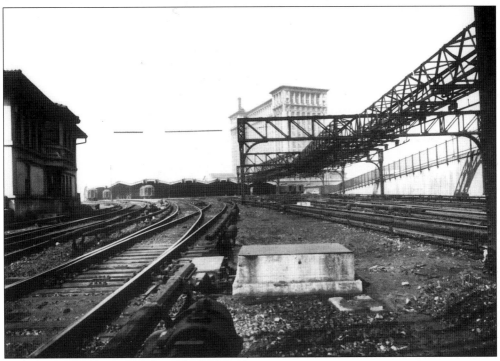

(Courtesy of the Burton Historical Collection)

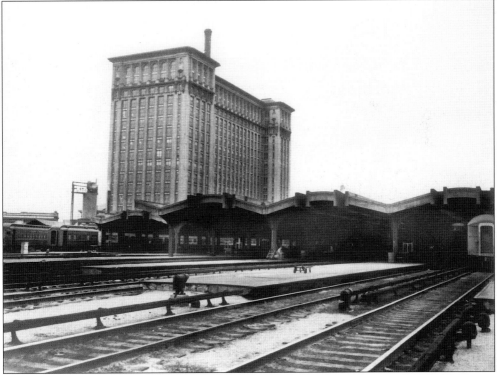

(Courtesy of the Burton Historical Collection)

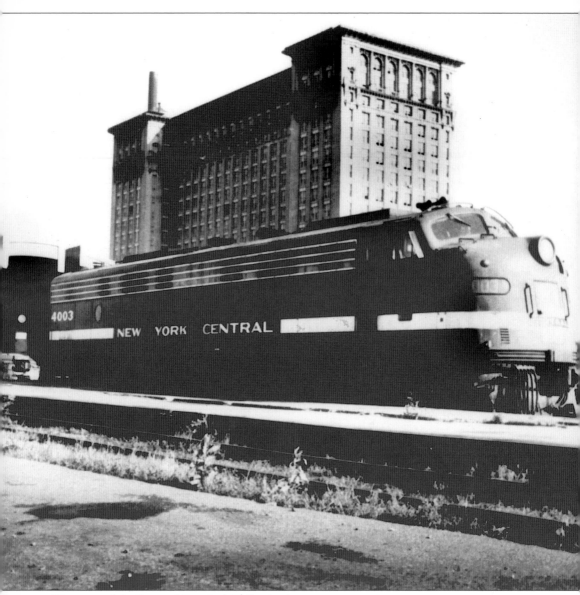

(Courtesy of the Burton Historical Collection)

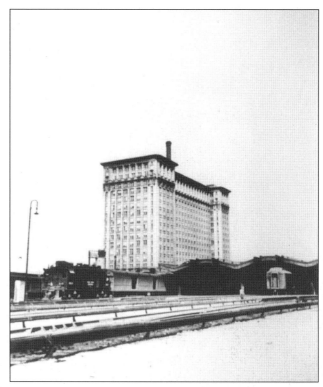

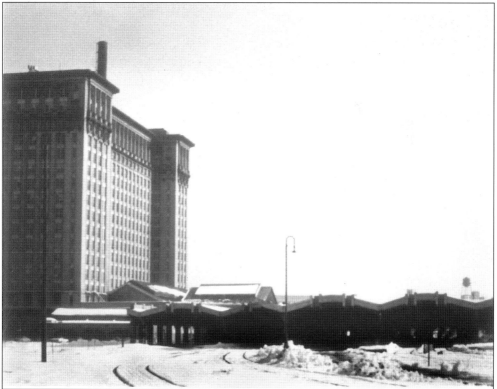

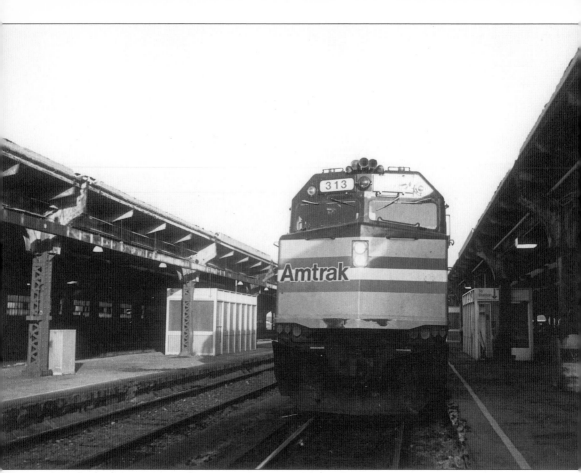

This is the end of the line. (Allan Barnes)

Seven
MEMORABILIA

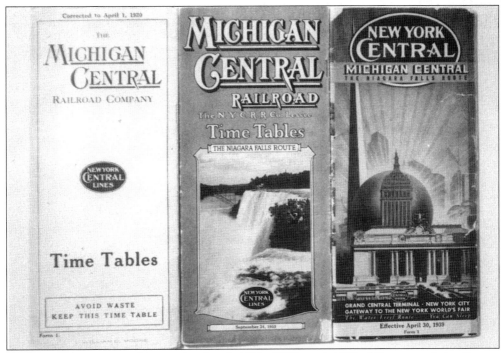

These are three time table covers, dated 1920, 1933, and 1939. (Courtesy of the Burton Historical Collection)

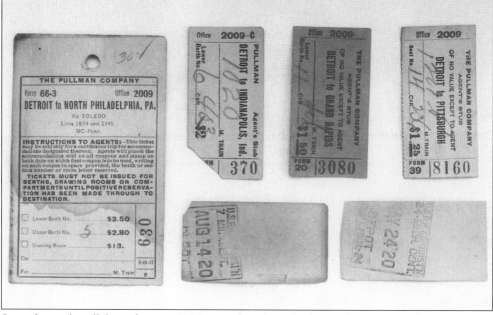

Six ticket stubs, all from the year 1920, were found inside the Michigan Central Station just a few years ago. (Courtesy of CJ Miller)

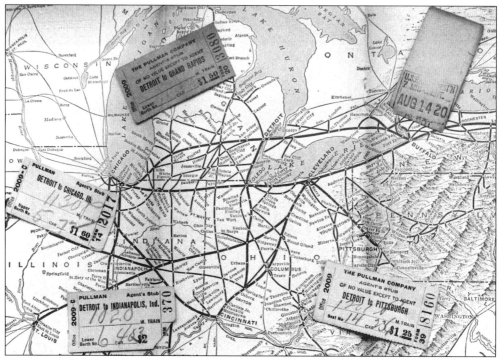

This map, taken from a 1940 timetable, is here depicted with ticket stubs placed at their final destination points. A sign of the changing times is printed on the cover: "Be Thrifty and Safe...Travel by Train"—no doubt a reference to the sizable bite air travel was taking out of train ridership. (Randa Haurani, Courtesy of CJ Miller)

The *Detroiter* left the Michigan Central each evening for New York City, and was know for its all-Pullman luxury. Henry Ford's private car, the *Fairlane*, was sometimes attached to the Detroiter. (Courtesy of CJ Miller)

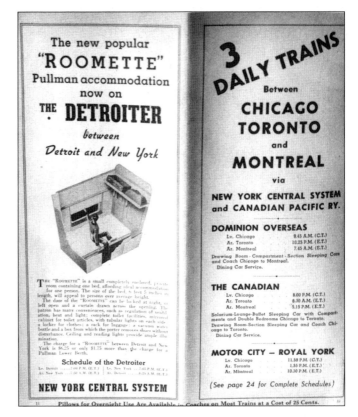

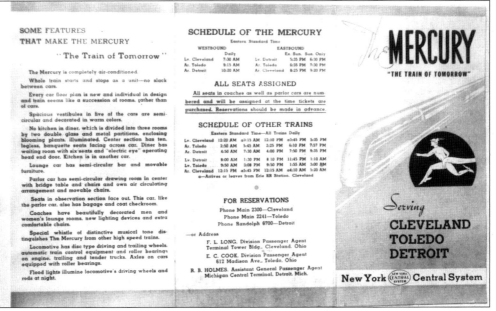

The *Mercury* made its debut in 1936, at first only serving Detroit south to Toledo and Cleveland, as seen here. The following year, a *Mercury* line to Chicago was added. (Courtesy of the Burton Historical Collection)

MOTOR CITY SPECIAL

A train of superior service including Single Bedroom Car between Chicago and Detroit.

Its Comfortable Lounge Car is a popular meeting place of business men from everywhere.

Valet Service for your Convenience

(Read down)			(Read up)
11.59 p.m...Lv. Chicago..(Central Time)...Ar.	7.20 a.m.		
6.50 a.m...Ar. Detroit..(Central Time)...Lv.	11.30 p.m.		
7.50 a.m...Ar. Detroit..(Eastern Time)...Lv.	12.30 a.m.		

Real Beds in Single Room Cars on the Motor City Special

These individual bedrooms were particularly designed for the occupancy of one person, but a door between each two rooms makes it possible to use them in suites of two.

The following tables show saving to the lone traveler who uses this car, the surcharge being included in the Pullman fares.

COMPARTMENT		SINGLE BEDROOM	
1½ Rail Fare - - $14.72		1 Rail Fare - - - - $9.81	
Pullman - - - - 10.50		Pullman - - - - - 6.75	
Total - - - $25.22		Total - - - $16.56	

MICHIGAN CENTRAL
"The Niagara Falls Route."

6

The *Motor City Special* traveled to Chicago. This advertisement was taken from a timetable dated September 24, 1933. (Courtesy of the Burton Historical Collection)

The *Wolverine* made a full run from Chicago to New York, and included an overnighter to Boston as well. Each morning, it left Detroit for Chicago. (Courtesy of the Burton Historical Collection)

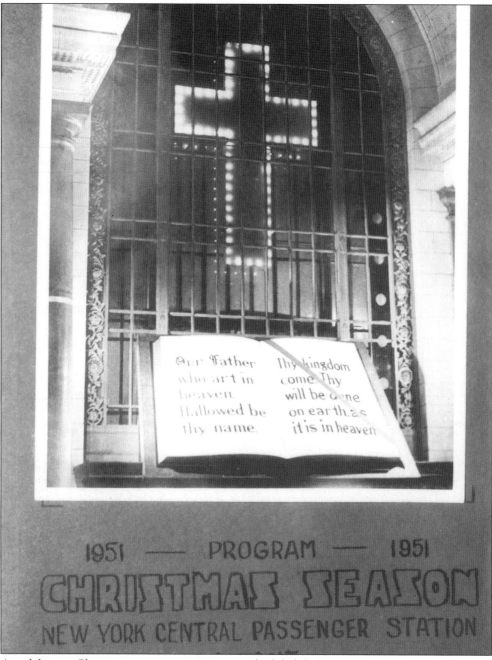

An elaborate Christmas season program was scheduled for 1951. The station was formally known as the New York Central Passenger Station since the 1930 merger of the Michigan Central Railroad and New York Central Railroad, although it remained commonly referred to as the Michigan Central Station.

The Christmas program featured music from December 14 through December 25, with choir performances from Ste. Anne's, St. Vincent's, Dominican High School, and various corporations. Santa arrived on the *Mercury* to dispense candy to children traveling over the holiday season. (Courtesy of the Burton Historical Collection)

Eight
1988–PRESENT

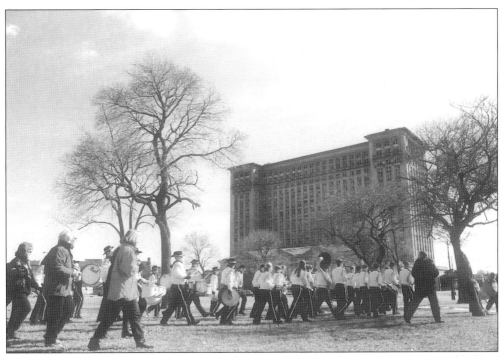

The annual St. Patrick's Parade, held each year on the Sunday prior to St. Patrick's Day, marches past the Michigan Central Station on March 15, 1998. Corktown, the neighborhood just east of the depot, has a strong Irish history that is celebrated each year at this time. Bagpipers, bands, and bars alike join in this rousing party, filling the streets with spirit. This photograph attests to the life that continues to swell from the communities surrounding the Michigan Central. (Tom Rinaldi)

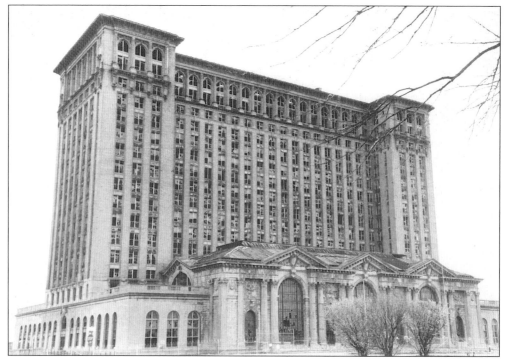

This haunting photograph, taken in 2001, is eerily reminiscent of the postcard rendering seen on page 23. (Randa Haurani)

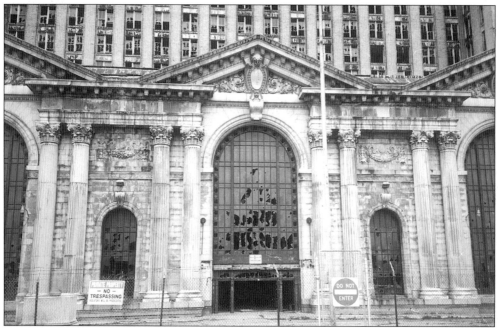

Many visitors to Detroit find themselves captivated by the mystery of the Michigan Central. A Dutch tourist snapped this photograph during his 1999 visit to the Motor City. (Hans Veneman)

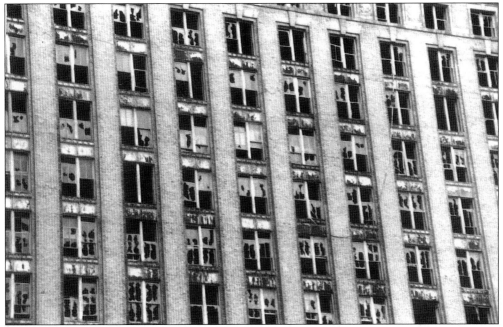

With such blight wrought on our bankrupt estate,
What ceremony of words can patch the havoc?
—Sylvia Plath

(Randa Haurani)

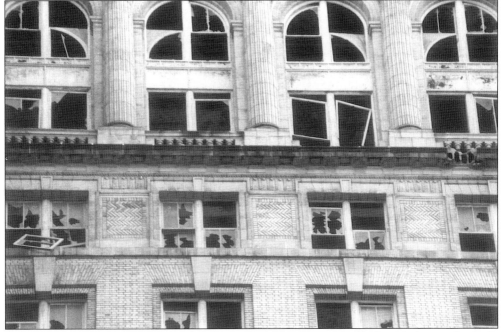

The intricate cornices, columns, lintels, and arches that ensured the Michigan Central's prominence throughout its tenure as an operating station remain a solemn testament to its storied life. (Randa Haurani)

95

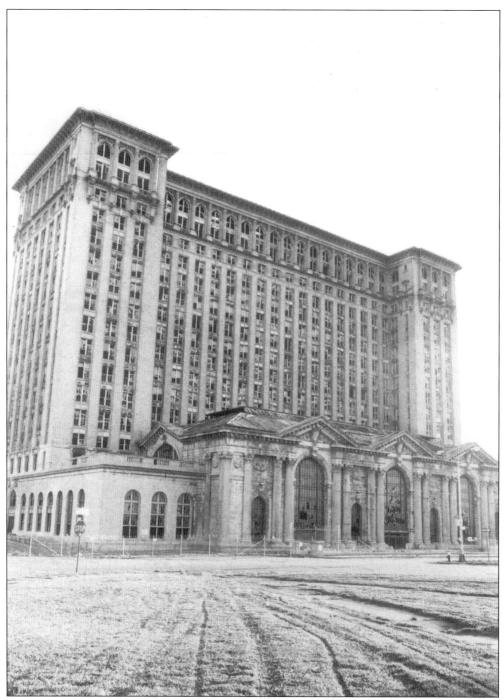

Tire tracks across Roosevelt Park evoke a sense of movement towards the Michigan Central—the irony being that the days of harried travelers rushing to and fro have long since vanished. (Randa Haurani)

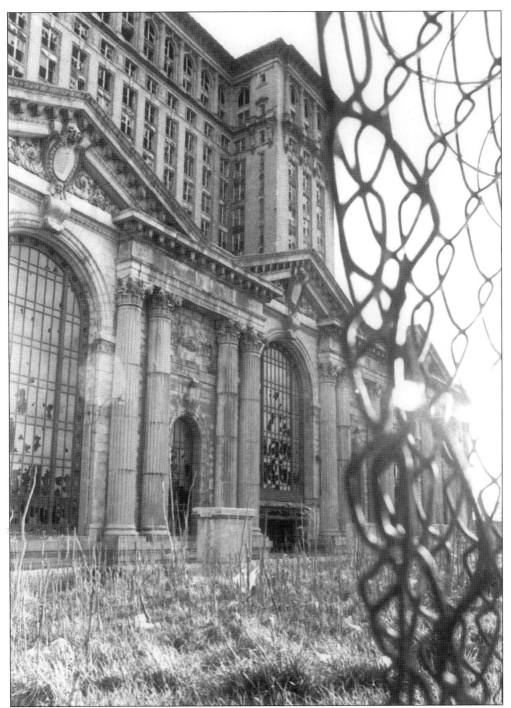

This photograph inadvertently reveals the tool used by scores of people determined to get inside this damaged, yet utterly compelling structure: the wire-cutter. (Randa Haurani)

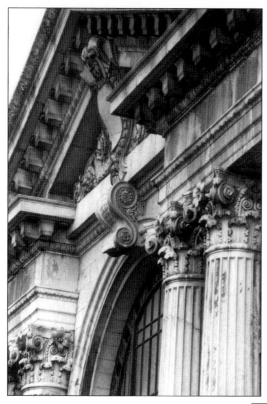

The elaborate capitals atop the columns and the intricate dentil work of the cornices certainly take inspiration from classical architecture. (Randa Haurani)

A strict attention to symmetry is another tenet of classical architecture the designers saw fit to employ. (Randa Haurani)

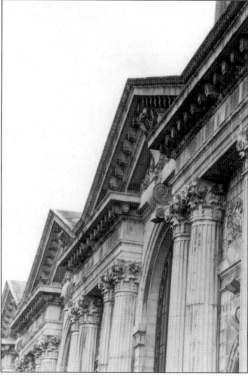

An intricately carved keystone completes this large arched window, one of which stands on either side of the main entrance. (Randa Haurani)

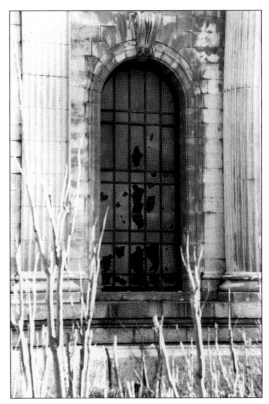

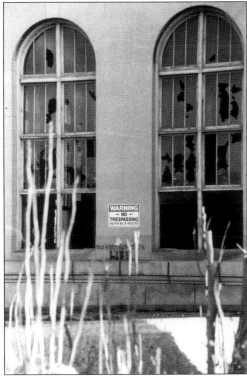

These windows once filtered light into the Women's Room, as seen on pages 50 and 51. (Randa Haurani)

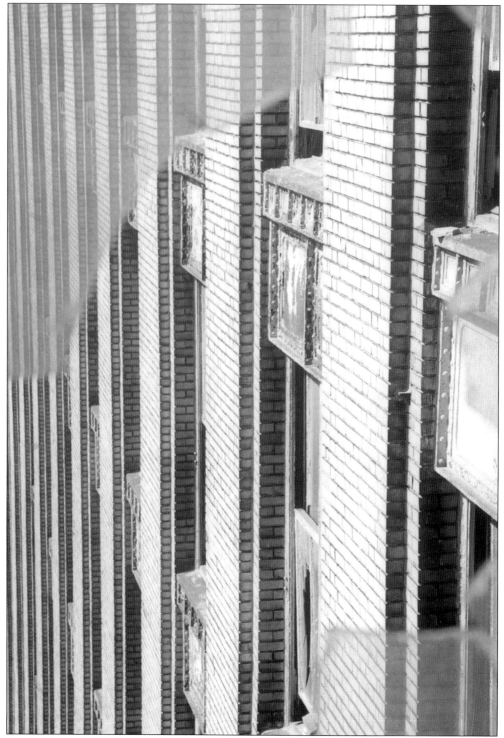

For the most part, the office tower portion of the Michigan Central employs a very simple design of rectangular windows and a brick-sheathed face. (Tom Rinaldi)

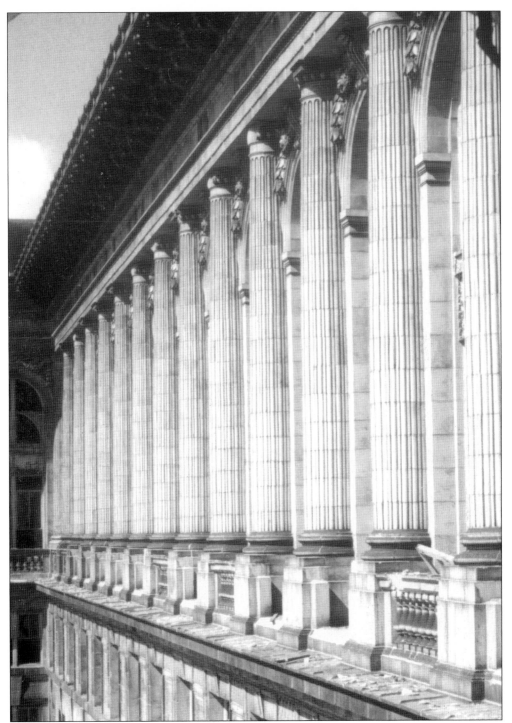

The Roman elements utilized at the base of the building are returned to, however, from the eleventh floor through to the top, or thirteenth, floor of the office tower. Seeing such components through a broken window does little to diminish the power of such complete repetition. (Tom Rinaldi)

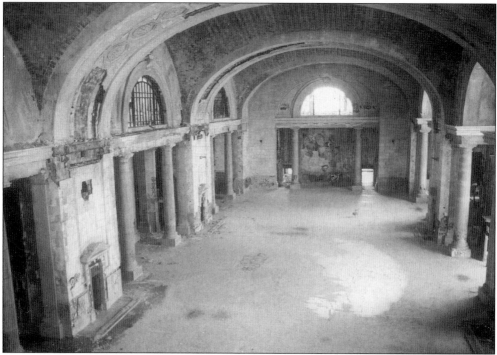

The waiting room has been stripped of much of its marble, its chandeliers, and the large bronze clock that once adorned the ticket windows. Many of the mahogany benches were sold for the paltry sum of $25 back during the time the main waiting room spent as a storage facility (see page 57). (Tom Rinaldi)

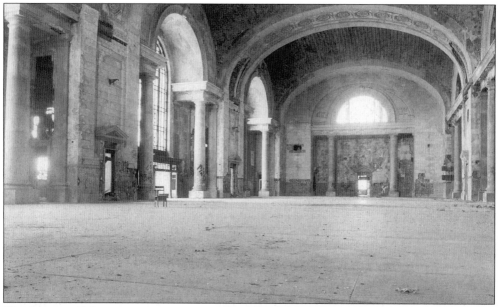

The vacancy of the waiting room seems only to heighten its massive sense of scale. The space measures 234 feet long by 98 feet wide, and the Doric columns surrounding it stand 21 feet high. (Tom Rinaldi)

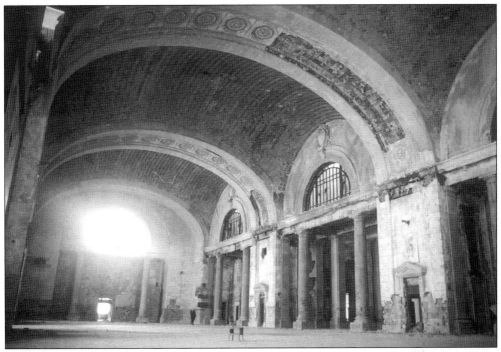

In the last two decades, the Michigan Central has had several owners: William Spencer of Citibank (1985–1989); Mark Longton, a Riverview developer (1989–1991); BSI Security Services, a Taylor firm that paid less than $80,000 for the station in an auction (1991–1994); and Control Terminals, a company related to the Detroit International Bridge Company, which also owns the Ambassador Bridge (1994–present). (Tom Rinaldi)

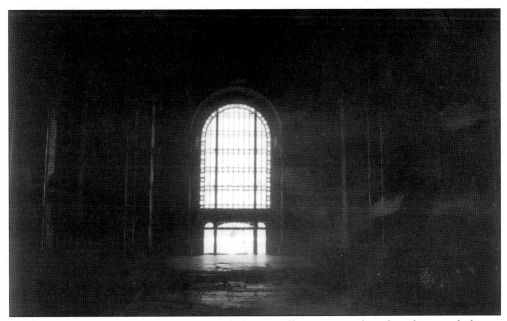

The lighting effect seen on pages 59 and 62 now illuminates only a lengthening darkness. (Jeremy Marentette)

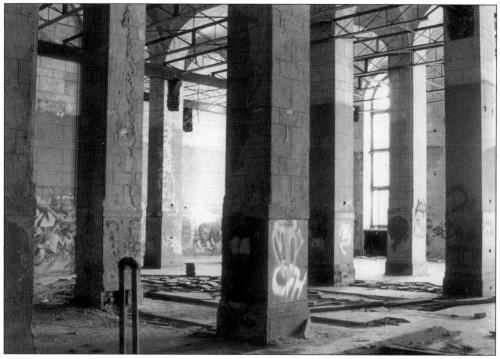

The remains of the dining room, pictured in better times on page 52. (Jeremy Marentette)

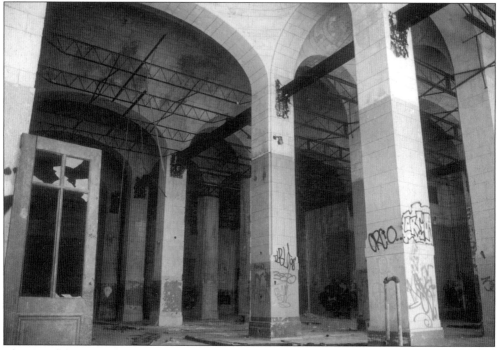

The metal framework seen near the top of this photograph is all that is left of the dropped ceiling once used to transform the dining room into its 1950's reincarnation as the *Mercury Room*. (Tom Rinaldi)

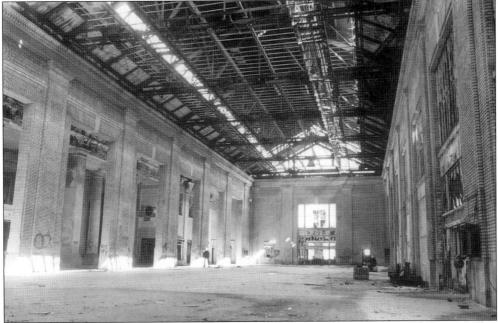

The concourse measures 78 feet wide by 204 feet long. Its walls are fashioned of light-colored brick laid in Flemish bond; the panels are outlined with terra cotta strips. The ceiling panels of copper frame the large skylights. (Tom Rinaldi)

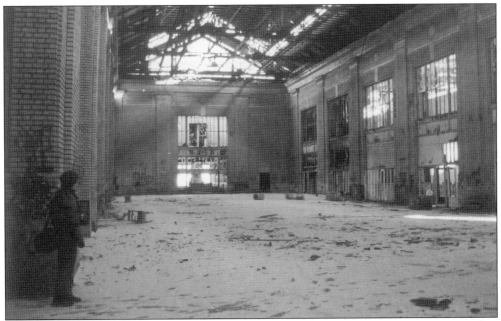

The New Friends of the Michigan Central Station, organized in 1993, strived to provide a physical and economic stimulus to preserve the Michigan Central. The group worked tirelessly for many years to prevent the deterioration seen in these photographs, to no avail. Activists such as Shirley Slaughter devoted countless time and energy to preserve that which they continue to view as a gem of the City. (Jeremy Marentette)

The bathrooms have long since been deprived of their sinks; the mirrors have long since ceased to reflect. (Jeremy Marentette)

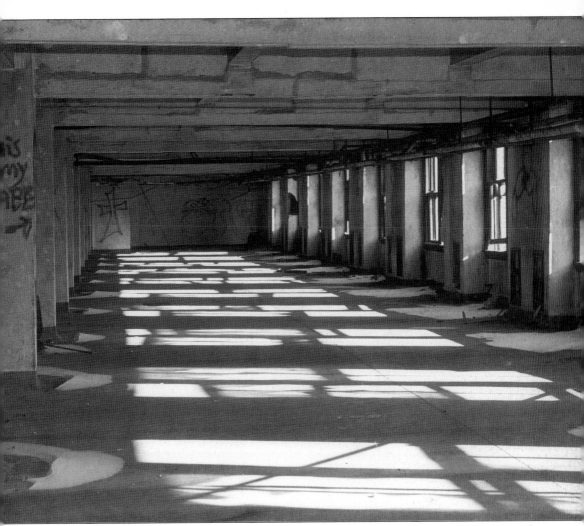

The symmetry of the exterior facade is here replicated in this interior interplay of shadow and light. (Jeremy Marentette)

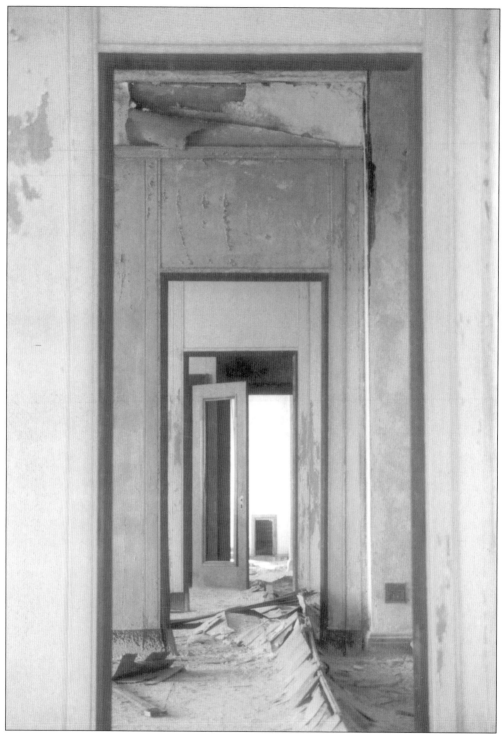

If the doors of perception were cleansed, everything would appear to man as it is, infinite.
—William Blake

(Tom Rinaldi)

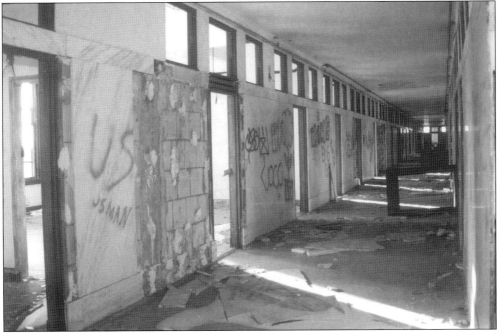

The marble wainscoting lining the walls of the 12-foot wide office tower corridor has been smashed and otherwise defaced throughout much of the building. (Jeremy Marentette)

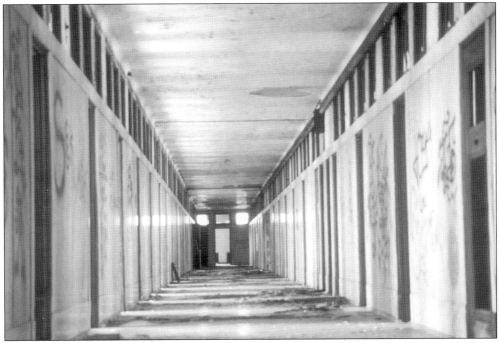

This view peers down an office tower hallway in much the same manner as the photograph on page 56. The thirteen floors of office tower have each approximately 18,000 square feet of space. (Tom Rinaldi)

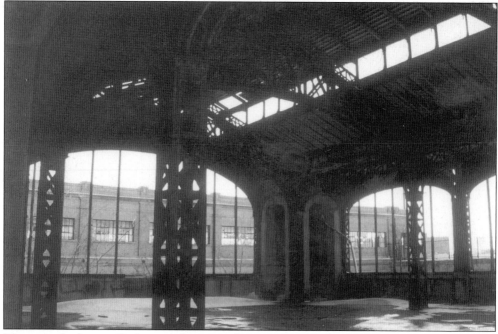

The train-sheds were Bushian in design, and were constructed to protect passengers from the elements while entering or exiting their train. (Jeremy Marentette)

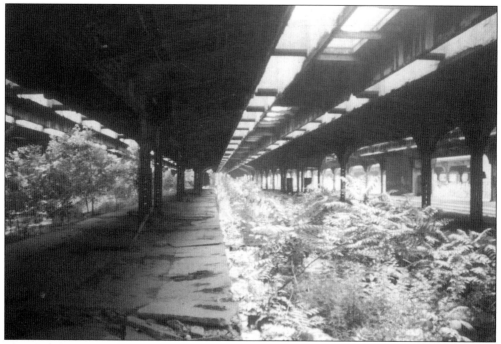

The skylights were cleverly executed in such a manner as to avoid the possibility of water backing up through the openings. To this end, copper flashing was employed around the openings and the large down spouts were heated with steam jets in cold weather to prevent their clogging. (CJ Miller)

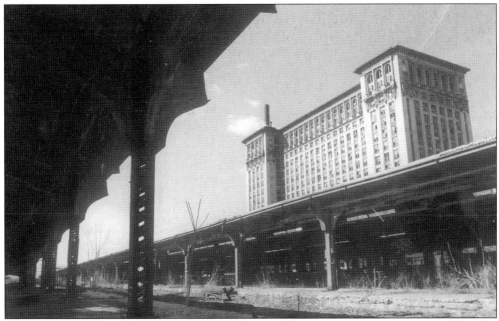

The trainsheds were 250 feet wide by 1,104 feet long, which covered eleven tracks. Although they were designed to be purely functional, their simplicity is visually striking. (CJ Miller)

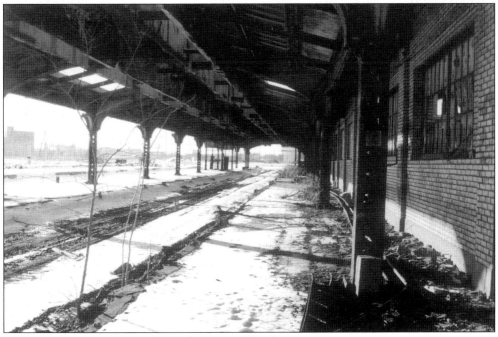

Standing at the station / But the train never comes
Still I'm hanging on / Like some old ghost town
—J.D. Souther & Dillion O'Brian

(Jeremy Marentette)

Architect Garnet Cousins, pictured here behind the station, took several of the photographs found in this book. Mr. Cousins received a Bachelor of Architecture degree from Lawrence Institute of Technology, for which his thesis was an analysis of the station. He and Paul Maximuke co-authored a seminal piece on the Michigan Central Station: "Detroit's Last Depot," a two-part serial published in *Trains Magazine* in 1978. (CJ Miller)

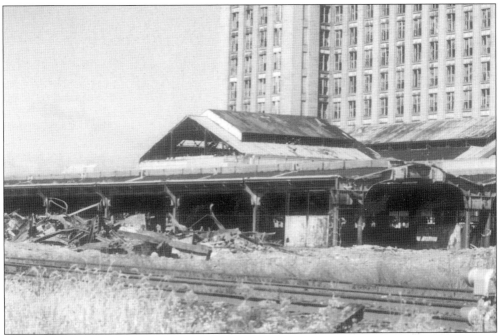

On this day in 2000, the trainsheds, which are on land controlled by Amtrak, were demolished to allow the site's use as an intermodal facility. Canadian Pacific Railroad leases the land necessary for this operation. (CJ Miller)

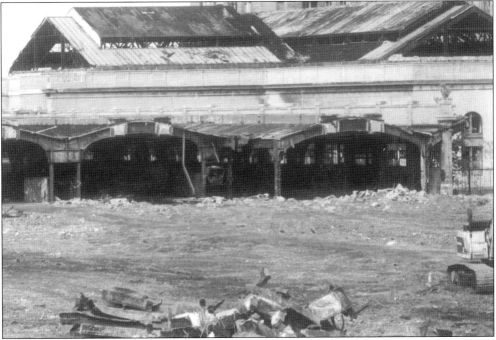

The loss of the sheds was disappointing to many Michigan Central lovers. Their utilitarian aesthetic was a perfect example of the modernist doctrine by which form follows function. (CJ Miller)

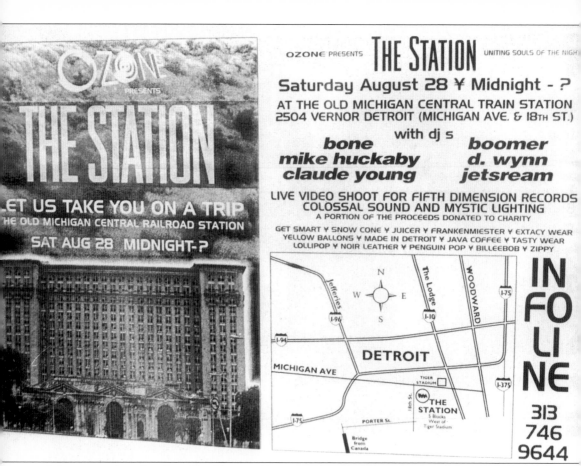

Like many other abandoned buildings in Detroit, the Michigan Central was host to a rave one evening. As this 1993 flyer indicates, several talented and still-prominent Detroit DJs headlined an event called "The Station." Apparently, police broke up the party before long—which is unsurprising, considering its extremely visible location. (Randa Haurani, courtesy of Mike Himes)

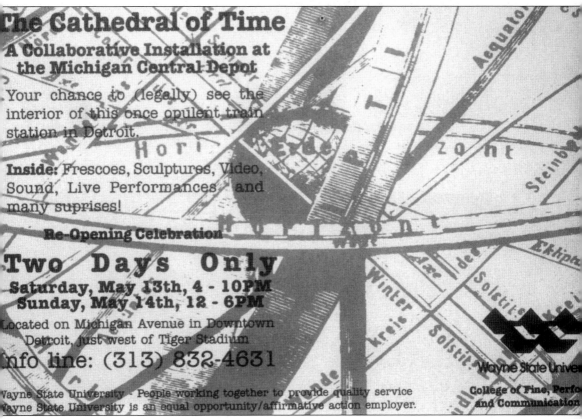

The Cathedral of Time

A Collaborative Installation at the Michigan Central Depot

Your chance to (legally) see the interior of this once opulent train station in Detroit.

Inside: Frescoes, Sculptures, Video, Sound, Live Performances and many suprises!

Re-Opening Celebration

Two Days Only

Saturday, May 13th, 4 - 10PM
Sunday, May 14th, 12 - 6PM

Located on Michigan Avenue in Downtown Detroit, just west of Tiger Stadium

Info line: (313) 832-4631

Wayne State University - People working together to provide quality service
Wayne State University is an equal opportunity/affirmative action employer.

Wayne State University
College of Fine, Performing and Communication

Another interesting use of the station came in 1995, when the Wayne State University School of Fine Arts created a multi-media collaborative installation entitled "The Cathedral of Time" at the Michigan Central. Visiting professor Irina Nakhova organized the exhibition, which is documented over the next three pages. (Courtesy of Irina Nakhova)

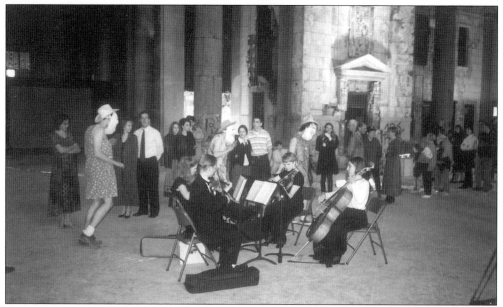

The conceptual framework for "The Cathedral of Time" was the idea of the Michigan Central as a Cathedral—a beautiful structure built as a testament to the human will—a symbol of prosperity (and decay) for the people of Detroit and America. This photograph documents the installation's opening celebration. (Courtesy of Irina Nakhova)

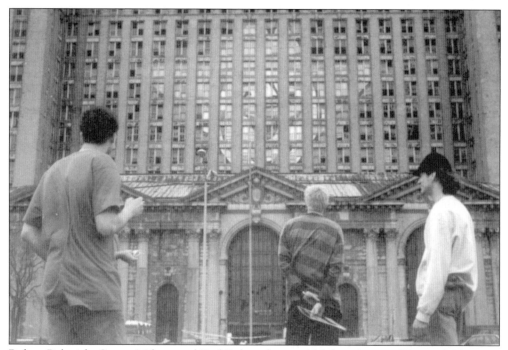

Robert Balavich, Conan Milner, and Karl Erikson hung a 100-foot mosaic of Farmer Jack across the windows of the station. Their work sought to symbolize the movement of old-fashioned commerce upon which much of this city's wealth was built. In the previous photo, you can glimpse one of the artists dressed up as Farmer Jack in drag. (Courtesy of Irina Nakhova)

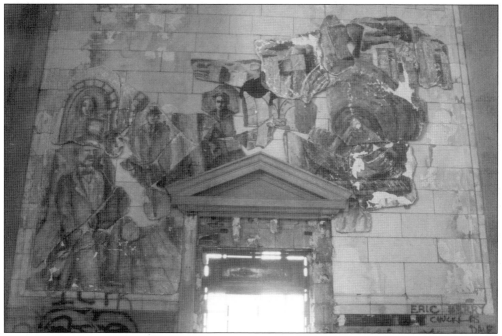

A group of painters created frescoes. This one illustrates the past, including images of religious figures and people of the 1920's. The second was a series of images about the abandonment of the city, and the third visualized a city that might one day be. Pieces of these frescoes can still be seen, as is evidenced by the photographs on page 102. (Courtesy of Irina Nakhova)

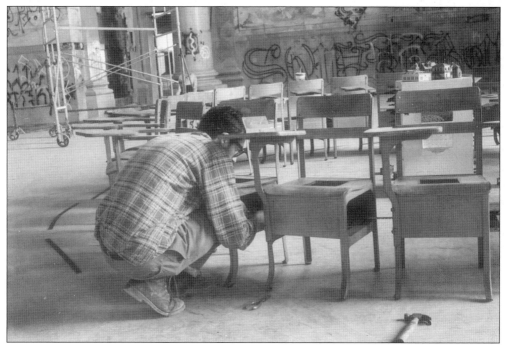

Phillip Burke opted to run a toy train though old school desks in order to demonstrate a love for trains shared by young and old alike. (Courtesy of Irina Nakhova)

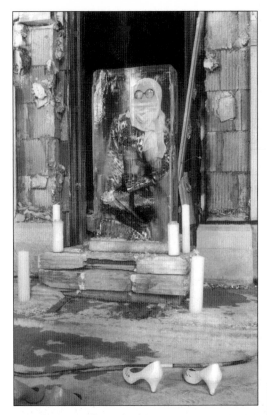

Lisa Dunn's ice sculpture melted over the period of the installation, in a reference to the passing of time. (Courtesy of Irina Nakhova)

Deborah Riley inhabited the station with ghosts of former travelers by stiffening old clothing with glue. (Courtesy of Irina Nakhova)

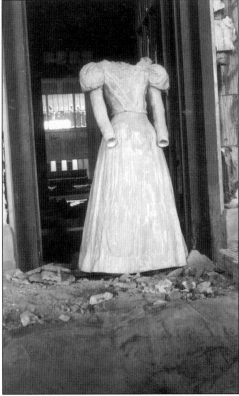

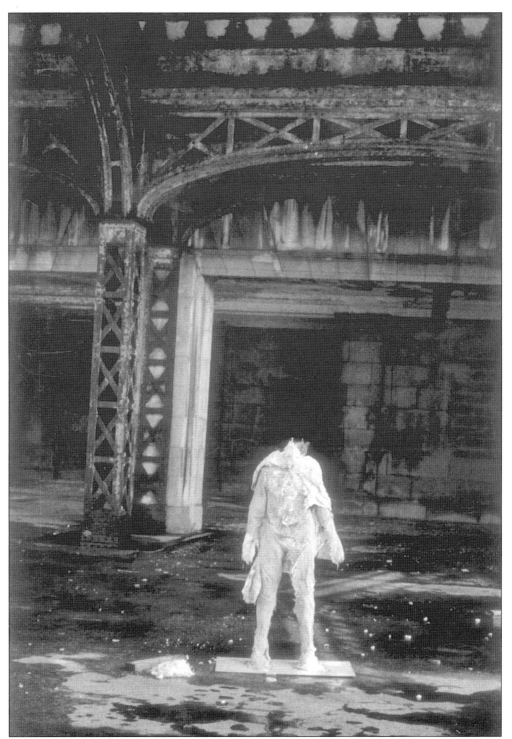

This photograph, taken years after "The Cathedral of Time" exhibition, seems perfectly in keeping with the spirit of the installation. It allows the viewer to experience a close encounter with the ghost of one of artist Deborah Riley's ghosts (previous page)—to stunning effect. (Mark Powell)

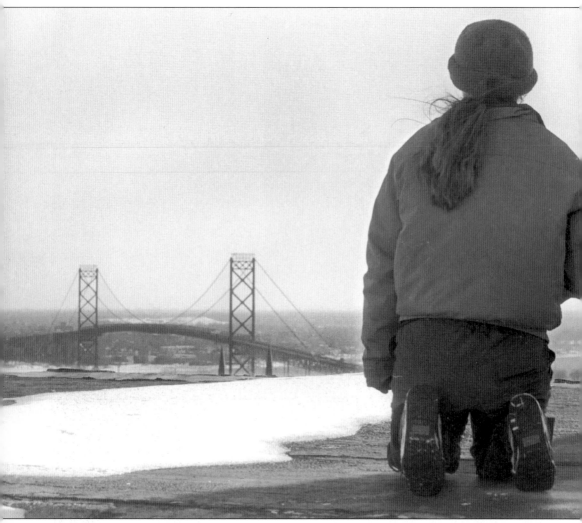

The sense of quiet and awe afforded such a rare roof-top perch is here captured. It seems quite appropriate that this view to the southwest takes in the owner of the Michigan Central Station's other monumental property: the Ambassador Bridge. Both iconic—one in constant use and repair, the other marginally maintained. (Jeremy Marentette)

Nine
FUTURE IMAGININGS

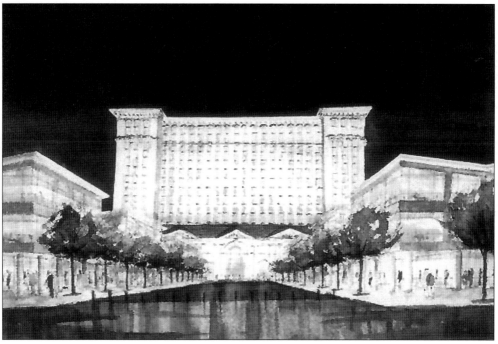

In 2000, the University of Michigan's Taubman College of Architecture + Urban Planning conducted a Design Charette, of which one focus was the Michigan Central Train Station. This watercolor image, produced by one group of students and professionals (known as Team One) depicts the station as a high-tech "incubator," conference center, and transportation hub.

Team One also saw the construction of mixed-use loft buildings to the front of the station as an important component of their plan. This, they believed, would promote activity in the neighborhood and bring a more human scale to the area immediately bordering the station. (Phil Jones, courtesy of Taubman College of Architecture + Urban Planning, University of Michigan)

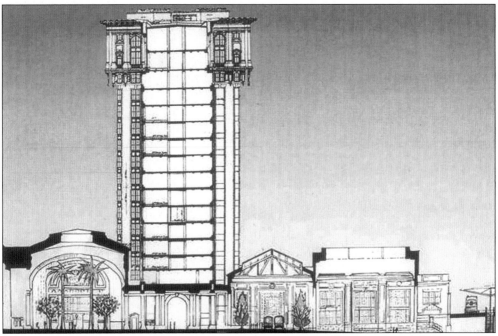

A cross section of Team One's plans details a diverse programming for the Michigan Central Station. To the far left of the drawing, a flexible room is made suitable for a variety of uses, such as large meetings, wedding receptions, or job fairs. The tower portion of the station would be home to a number of technology- and information-based businesses. The station remains partially used in its original manner, becoming a stop for a future high-speed rail system linking Detroit to Chicago and Toronto, as shown at the far right side of the drawing. (Phil Jones, courtesy of Taubman College of Architecture + Urban Planning, University of Michigan)

Furthermore, Team One transformed the concourse into an all-weather waiting room for a downtown shuttle. This electric shuttle would travel directly into the space, transporting tourists, clients, and employees of the many businesses housed within the tower, as well as residents of the newly constructed depot district. (Phil Jones, courtesy of Taubman College of Architecture + Urban Planning, University of Michigan)

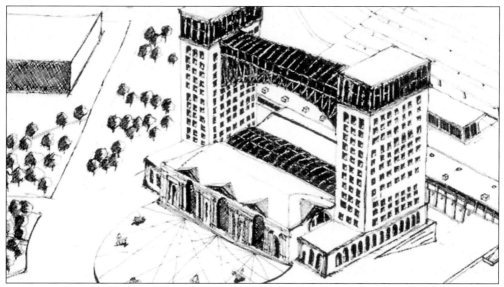

Team Three proposed this compelling and controversial idea for a Michigan Central re-use and rehab that focuses on the station as a visual landmark. It considers the fact that the sheer amount of building to be renovated could be considered prohibitive and works to bring Roosevelt Park out from the literal shadow of the train station.

This concept removes the middle section of the office tower, thereby reducing renovation costs and parking needs. A bridge housing a restaurant and viewing platform straddles the remaining end towers. (Phil Jones, courtesy of Taubman College of Architecture + Urban Planning, University of Michigan)

The University of Michigan Charette also included the participation of five artists who were encouraged to explore the interface between aesthetics and the more pragmatic concerns of the architects and planners involved in the exercise. Pictured here is Yvette Amstelveen's *Railwave*, which not only functions as an innovative playscape, but symbolically extends the rails of the train station to the public face of the building. (Phil Jones, courtesy of Taubman College of Architecture + Urban Planning, University of Michigan)

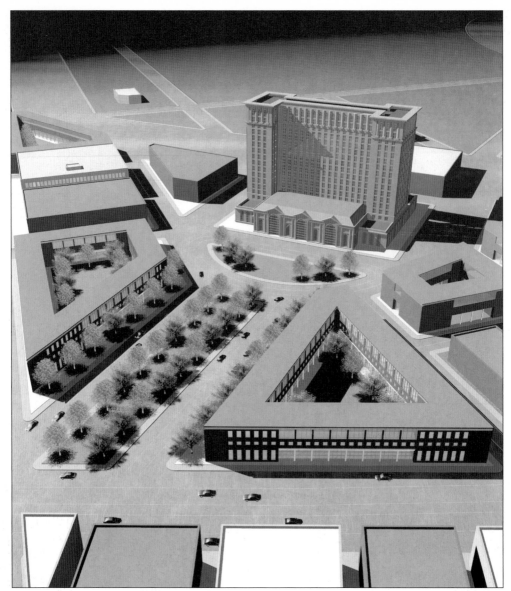

On March 1, 2001, the Detroit International Bridge Company, owner of the Michigan Central Station, hosted a community forum regarding a potential rehabilitation of the structure. Residents of Corktown and Mexicantown gathered to voice their ideas for the building as well as their concern over its current condition. The Bridge Company hired consulting architects to both moderate the meeting as well as document relevant issues and concepts.

The linchpin of the resultant plan, depicted here, would be the use of the station's tower as an International Trade Processing Center—imagine a high-tech customs facility, facilitating international trade throughout the region. The surrounding district—excepting the central sweep of Roosevelt Park—would be infilled with mixed-use, new construction. (Courtesy Detroit International Bridge Company)

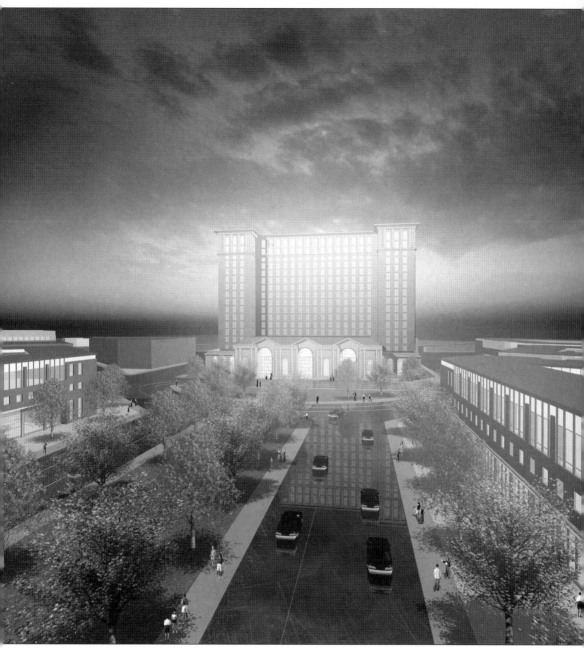

The architects of note for this ambitious project, Luis Antonio Uribe of 511 Arquitectura and Doug McIntosh of McIntosh Poris, are faced with a difficult challenge: they must balance the needs of a corporation, naturally eyeing the bottom line, with those of wary residents and a beloved historic structure.

The logistics involved before undertaking such a project include a feasibility study, structural analysis, and renovation estimate. One can only hope that some day this plan will come to fruition, and that these renderings will stand as a record of not just another imagined dream, but a reality. (courtesy Detroit International Bridge Company)

Afterword

From the moment the Michigan Central Station was expressed as a series of pencil lines on a sheet of paper, it seems to have been a portrait of duality. The very location of the depot places it in the midst of a century-long battle between mass transit and personal transportation, and between downtown/industrial sprawl and the needs of urban residential neighborhoods.

The two architecture firms bestowed the honor of designing the depot were also a study in contrast. Warren & Wetmore were renowned hotel designers, while Reed & Stem established their reputation in the railroad station business. Previously joined together in the New York Grand Central Station commission, the unusual pairing, while yielding a much-loved building in the Michigan Central, resulted in a swirl of criticism as well.

The virginal expanse of meticulously planned Roosevelt Park contrasts with the simple grace of the purposefully plain train sheds. On the interior, the stark elegance of unadorned walls necessarily gave way to a helpful, yet cluttering, display of directional signage. Even now, in its current state of decay, the station defiantly exudes beauty. Like a toothless smile, its windows speak of hardships as well as hopes.

Now, in 2001, a compromise must be made between economics and nostalgia. Personally, I view the Michigan Central as an iconic structure, more so than as a practically wrought facility. In short, I see the Michigan Central partially restored in order to serve a symbolic function in much the same way as the Eiffel Tower does in Paris. With the main floor fully renovated and the bare tower lit from within, the Michigan Central could stand as a beacon of light for the City of Detroit.

I encourage a celebration of the contradiction inherent in the scale of the Michigan Central. Proudly overbuilt, it now hovers over—while standing apart from—its city. Inasmuch as part of Detroit's charm and spirit can be found in juxtapositions and oppositions, so stands the Michigan Central Station.

Bibliography

The following sources were referenced in my research; the listings followed by () were of particular help.*

Benson, Robert. "Will Somebody Save This Station?" *Detroit Free Press*, 05 December 1982.

Brauer, Molly. "Depot's Back on Track." *Detroit News*, 08 July 1986.

———."Train Depot Gets New Lease On Life." *Detroit News*, 27 July 1988.

Burton A.I.A., Robert Ellis. *Detroit Terminal—Conrail*. Newtown Square, PA: May 1979. (*)

Chargot, Patricia. "A Golden Age Rolls to an End as Train Depot Shuts its Doors." *Detroit Free Press*, 31 December 1987.

Child, Charles. "Central Depot is for Sale." *Crain's Detroit Business*, 28 May 1990.

Cook, Louis. "Dusting Off Penn Station." *Detroit Free Press*, 22 August 1975.

Cosgrove, Bob. "Behind the Depot." *On Track with the New Friends of the Michigan Central*, November 1993.

Cousins, Garnet R. and Paul Maximuke. "Detroit's Last Depot, Part 1: The Station that Looks Like a Hotel." *Trains Magazine*, August 1978: pages 40–48. (*)

———. "Detroit's Last Depot, Part 2: The Ceremony was 61 Years Late." *Trains Magazine*, September 1978: pages 44–51. (*)

Dickerson, Marla. "Security Firm Wants Depot Sold to Pay Debt." *Detroit News*, 01 March 1991.

———. "Debt to Force Auction of Old Railroad Depot." *Detroit News*, 03 May 1991.

———."Security Firm Buys Train Depot at Auction." *Detroit News*, 02 July 1991.

Feresten, Timothy. *Photography Site*, 20 November 2000. http://www.ferestenphoto.com/trainsta.html.

Gallagher, John. "Michigan Central Owner Wants Station to Bustle Again." *Detroit Free Press*, 08 November 1990.

———."The Little Train that Could." *Detroit Free Press*, 23 May 1994.

Kane, Edward W. State of Michigan, Department of Treasury. Letter to Garnet R. Cousins, 15 January 1975.

King, R.J. "Bridge Owner Buys Train." *Detroit News*, 13 November 1996.

Lochbiler, Don. "Ghostly Rail Terminal Renamed." *Detroit News*, 29 September 1968. (*)

Markiewicz, David A. "Standing By for a Miracle." *Detroit News*, 16 October 1989.

McKee, J.L. New York Central System. Letter to Danhof et al., 03 April 1941.

Mieczko, Louis. "It's End of Line for Michigan Central." *Detroit News*, 23 December 1987.

Miller, C. J. *Motorless Detroit*, 28 March 2000. http://www.michigangolfing.com/motor/mcs.htm.

Miro, Marsha. "Terminal Optimism." *Detroit Free Press*, May 1995.

Nelson, Roland D. and Laurence G. Allen. *Detroit Passenger Terminal—Conrail*. Detroit: Dean Appraisal Company, 1979.

Noseworthy, L.M. New York Central System. Letter to Chester F. Mally, President, Mally Corporation, 21 February 1963.

Powers, Mark. "Art Installation to be Housed in Old Michigan Central." *The South End*, 11 May 1995.

Rinaldi, Tom. *Around Town with Tommy*, 14 March 2001. http://www.people.fas.harvard.edu/%7Eecorwin/tom/MCS.htm

Smith, Dena. "A Ticket to the Past." *Metro Times*, 15–21 May 1996.

Styrlander, Erik. "The Depot: a Hollow Shell of Memories." *Detroit News Pictorial Magazine*, 05 June 1966.

Ter Horst, J.F. "Railroad Glories Fade with Sale of NYC's Station." *Detroit News*, 21 August 1956.

Trent, Kim. "Scavengers are Gutting Michigan Central Depot." *Detroit News*, 16 September 1991.

Vergara, Camilo Jose. "Michigan Central Railroad Station, Detroit." *Michigan Quarterly Review*, Summer 1999.

Vicari, Tonino Joseph, ed. *Michigan at Trumbull: Turning the Corner*. Ann Arbor: A. Alfred Taubman College of Architecture and Urban Planning—University of Michigan, 2000. (*)